Barthes / Burgin

Barthes / Burgin

Research notes for an exhibition
Edited by Ryan Bishop and Sunil Manghani

EDINBURGH
University Press

Edinburgh University Press Ltd
The Tun - Holyrood Road, 12(2f) Jackson's Entry,
Edinburgh EH8 8PJ

www.euppublishing.com

Typeset in Winchester School of Art
by Studio 3015, and printed and bound
in Wales by Gomer Press Ltd, Ceredigion

A CIP record for this book is available from
the British Library

ISBN 978 1 4744 1553 8 (paperback)
ISBN 978 1 4744 1554 5 (webready PDF)
ISBN 978 1 4744 1555 2 (epub)

Barthes' drawings are reproduced courtesy of the
Bibliothèque nationale de France and by the kind
permission of Éric Marty.

The exhibition *Barthes / Burgin* shown at John Hansard
Gallery, 13th February – 16th April 2016, has been
financially supported by The Henry Moore Foundation

John Hansard Gallery is funded by the University
of Southampton and Arts Council England.

John Hansard Gallery Supported using public funding by ARTS COUNCIL ENGLAND The Henry Moore Foundation

Contents

Acknowledgements

Bringing to fruition the exhibition *Barthes / Burgin* at the John Hansard Gallery inevitably involved the key help and support of friends and colleagues. At the John Hansard Gallery, Stephen Foster, Ros Carter and the fantastic team there made all of this possible. The Henry Moore Foundation provided financial support for the development of the exhibition and Victor Burgin's new commission.

Robert E. D'Souza, head of the Winchester School of Art, as well as our many and excellent colleagues and students there contributed greatly and generously to the intellectual shape of this exhibition through discussions, seminars, presentations and hallway chats. We are also indebted to Céline Flecheux and Michel de Dadelsen in helping to facilitate access to Barthes' drawings, along with the expert assistance and advice of conservators Marie Odile Germain and Guillaume Fau at the Bibliothèque nationale de France, and the support of their wider team. A particular note of thanks goes to Éric Marty for permission to exhibit the works and reproduce them for this book. We are very grateful to the design team at WSA, Studio 3015 led by Jodie Silsby, Patrick Nicholas and Katie Evans, who worked tirelessly to realise the overall look and layout of this book. Special thanks goes to Ian Davidson and the production group at Edinburgh University Press. Our editor Carol MacDonald, once again, supported, guided and encouraged us at each step, for which we owe her our endless gratitude and appreciation. Finally a very special thanks to Victor Burgin, for his work, patience and care with this project.

Preface

Stephen Foster

This book was published to coincide with the exhibition *Barthes / Burgin* at the John Hansard Gallery in 2016. The exhibition is the last in the old building that John Hansard Gallery has occupied for the last thirty-five years on The University of Southampton's Highfield campus. The Gallery has, for most of that time, been driven by an exploration of the development of early conceptual art and the theoretical ideas that helped to shape it. It is therefore entirely appropriate that the final exhibition in this iteration of the Gallery's history should include one of the key figures to have had such an influence on art, and particularly photography, history and theory. Roland Barthes' drawings represent another aspect of his work and have never been exhibited in Britain before. This small sample of his desk-based drawing practice is exhibited alongside one of the key figures in the development of conceptual art from the 1960s, Victor Burgin, showing three new projections, one specially commissioned by the John Hansard Gallery relating to its own history. This publication and the exhibition examines the relationship between the thinking and theoretical positions occupied by Barthes and which had such an influence on Burgin's own writing and his work as a visual artist.

At the root of this relationship is the place of the author and of the spectator in relation to the work of art. In Barthes' case this moved from various theoretical positions into an increasingly creative or poetical interpretation, culminating in his final published work, *Camera Lucida*. The fact that this latter period in Barthes' life was accompanied by a routine practice of making desk-based drawings may be of particular significance. Burgin, on the other hand, originally engaged in the openly political use of, initially photographic-with-text based works towards an increasingly poetic interpretation of his subjects which emphasised the lack of importance of the artist in terms of meaning in the work of art, and particularly its interpretation among the audience.

The publication *Barthes / Burgin* makes use of the slash which was so significant to Barthes as a signifier of the relationship between the word on either side of it. This is reflected in the exhibition, which has Barthes' drawings running through the middle of the exhibition as a constant reminder of the significance of Barthes' thinking to Burgin's own. While there is no apparent relationship between Barthes' drawings and

Burgin's works, as the authors of this volume point out, there is a relationship based on the pair's theoretical positions.

The exhibition features three new works by Victor Burgin not seen in Britain before, and which all deal with a disappeared building. The first, *A Place to Read* features a disappeared coffee shop in Istanbul. The second, *Prairie,* is about the demolition of the Mecca in Chicago which was replaced by Crown Hall, the home of architecture at the Illinois Institute of Technology, built by Mies van der Rohe. The third, *Belledonne,* commissioned especially for the exhibition, is about the imminent disappearance of the building that the John Hansard Gallery has occupied since its founding in 1979. Burgin layers the history of the Gallery with a panoramic, postcard view of Belledonne in Southeast France, which was the location of a sanatorium in which Roland Barthes was a patient between 1942-5. *Belledonne* will be re-shown in the new John Hansard Gallery, which is a new purpose-built gallery in the centre of the city of Southampton. By then the piece will have become a commemoration of a disappeared building while at the same time it will help to create a sense of continuity between the old building and the new.

We are extremely grateful to the authors of this volume and co-curators of the exhibition, Ryan Bishop and Sunil Manghani. And, of course, our special thanks go to Victor Burgin, whose response to the invitation for the exhibition, the commission and this publication was so warm and fulsome.

Barthes, Burgin, *Barre oblique*

Ryan Bishop and Sunil Manghani

This book brings together a set of critical commentaries and dialogues on the occasion of the exhibition *Barthes / Burgin,* held at the John Hansard Gallery (University of Southampton), in 2016. It serves as both a short-form catalogue and critical contextualisation of the works on display, which brings together drawings by Roland Barthes from the 1970s and recent projection works by Victor Burgin, including a newly commissioned work for the show. The title of the exhibition plays with the slash or 'dividing bar' as established in semiology's system of signifier and signified, echoed for example in the title of one of Barthes' key texts *S/Z* (1974), which itself marked an important shift to post-structural writing. Both the exhibition and the texts collected here aim to offer a reading of Barthes, Burgin and the two in relation to one another. The 'dividing' line, or rather the slash as critical interstice, is intended to allow for a range of responses, relations, differences and oscillations to be considered between both writers/artists. The influence of Roland Barthes on Burgin's work is well documented, not least by Burgin himself (with further consideration offered in this book, with the chapter 'Reading Barthes'). Equally, of course, Burgin's prominence as an artist and theorist, concerned with text and image and the confluence of semiotics and psychoanalysis, offers a challenging dialogue with Barthes' work. An important tenet of the exhibition has been to consider Burgin and Barthes as being both artists and writers. Victor Burgin has long been recognised as both theorist and practitioner, while Barthes is known as a theorist and writer. In bringing to the fore Barthes' own sustained practice of painting and drawing (maintained throughout the 1970s), the book seeks to prompt a new critical consideration of Barthes/Burgin, theory/practice, writing/making and criticality/visuality.

Barthes /

The French literary and cultural theorist, Roland Barthes, writing in the 1950s through to the end of the 1970s, is perhaps best known as a prominent architect of semiotics. As a method of cultural and literary analysis, semiotics has been applied to a vast array of 'texts', from popular and classic literature to theatre, painting, television, film, advertising and fashion. Its development is attributed to the work of the Swiss linguist Ferdinand Saussure (1857–1913), who offered a systematic view of modern linguistics based upon a dyadic model of the 'sign'. The system is based upon a signifier, as an identifier of meaning (e.g. a word or a sound), and the signified, being the thing or concept corresponding to the signifier. Saussure's work ushered in a whole intellectual movement referred to as structuralism, since the concept of the sign presented a structuralist account of language. The sign as a unit of meaning only makes sense in relation to a wider system or structure of meanings. In itself, the sign does not have any intrinsic meaning. Instead there is an arbitrary relation between the sign and the thing it represents. This understanding of the arbitrary nature of the sign, as underpinning a system of meanings, led to the pervasive use of semiotics across a wide range of disciplines and domains. Barthes' contribution to the field, best known with the publication of his book *Mythologies* in 1957, not only helped give political depth to Saussure's speculative theory, but also paved the way in applying semiotics to all manner of cultural phenomena, including the visual arts.

Roland Barthes' writings continue to resonate with literary and arts scholarship today and indeed there is a large and growing audience regarding his work. Echoing in some respect the wealth of publishing of works both by and about Walter Benjamin in the last couple of decades, there has been something of a 'return to Barthes'. Stemming from around 2002, with the Pompidou Centre's exhibition of Barthes' life and works (Alphant and Léger 2002), a 'new' Barthes has emerged, informed importantly by the posthumous publication of a wide range of materials. Most significantly, this includes his final three lecture courses at the Collège de France of the late 1970s. The first of these was only published in French in 2002, and more recently in English by Columbia University Press under the titles of *How to Live Together* (2013), *The Neutral* (2005), and *The Preparation of the Novel* (2011). In addition *Mourning Diary* was published in 2012 and *Travels in China* in 2013. These later writings have prompted renewed scholarship, captured for example by 'The Renaissance of Roland Barthes' conference held in New York in 2013, with key speakers including Rosalind Krauss and Jonathan

Culler, whose papers can be read online with a special issue of *The Conversant* (<http://theconversant.org>). Barthes remains a much-cited author in a wide range of literature. A notable example of recent secondary literature is Geoffrey Batchen's edited volume *Photography Degree Zero* (2009), which includes Burgin's essay 'Re-reading Camera Lucida' (31–46). In addition a new journal, *Barthes Studies,* which describes itself as 'an open-access journal for research in English on the work of Roland Barthes', has been set up by Cardiff University (<http://sites.cardiff.ac.uk/barthes/>).

Preparations for the exhibition at the John Hansard Gallery were taking place through 2015. The year marked Barthes' centenary, which only fuelled further interest. Writing in the *Times Literary Supplement* (Badmington 2015), in reviewing Tiphanie Samoyault's (2015) critically acclaimed new biography *Roland Barthes* and the centenary exhibition held at the Bibliothèque Nationale de France, Neil Badmington refers to a 'Barthes-athon' taking place over the centenary year. By the end of the 2015, he notes, 'celebratory events will have taken place in Paris, Bordeaux, Orthez, London, Providence, Lisbon, Taru, Leeds, Cardiff, La Paz, Londonrina, São Paulo, Bucharest, Bayonne, Kaslik, St Petersburg, Buenos Aires and Zagreb'. Added to which, the fashion house Hermès unveiled a silk scarf inspired by Barthes' *A Lover's Discourse* (1978). There have been a number of significant new publications. Of Barthes' own writings these include a large volume of previously unpublished writings, *Album: Inédits, correspondences et varia* (2015); and new editions of *La Préparation du roman* (2015) and *L'Empire des signes* (2015). Of volumes about Barthes, these include: Fanny Lorent's (2015) *Barthes et Robbe-Grillet: Un dialogue critique;* Magali Nachtergael's (2015) lavishly illustrated *Roland Barthes contemporain;* Chantal Thomas's (2015) *Pour Roland Barthes* and Phillipe Sollers' (2015) *L'Amitié de Roland Barthes.* In English translation, seven volumes of previously untranslated material have been released by Seagull Books (University of Chicago Press).

However, among all of these publications and scholarly events, very little, if anything, has been noted about Barthes' drawings and paintings. Indeed, the fact that Barthes sustained a practice of drawing and painting throughout the 1970s is little known, or at least rarely referred to. Barthes himself makes little reference to this fact. A hint is given in *Roland Barthes* (Barthes 1977). There are two illustrations of his paintings. One of which, made on college headed paper, is given the wry caption as simply 'squandering?' (a nod perhaps to Michel De Certeau's reappropriation of systems and of consumption as production). The penultimate page of *Roland Barthes* is given over to two further drawings or markings. The first suggests Barthes' interest in

Japanese calligraphy, with neat, proportioned figures, yet is labelled 'Doodling'. This is followed by a line of asemic writing, being a form of writing without determined characters or specific semantic content. This is captioned: '. . . or the signifier without the signified' (Barthes 1977: 187). There is also an elegant note on how Barthes established his working space, which includes a space for painting: 'My body is free of its image-repertoire', he writes', 'only when it establishes its work space. This space is the same everywhere, patiently adapted to the pleasure of painting, writing, sorting' (38).

These references aside, Barthes offers no commentary on his practice of painting. In the posthumously published lectures on the Neutral, in an aside, he refers to his practice as amateur, noting it as 'marginal, [a] type of *violon d'Ingres'* (Barthes 2005: 140). Yet, it should be noted, the figure of the amateur is important to Barthes, particularly in his move to more post-structural thinking. Making use of a range of mediums, from oils and acrylics to felt-tip pens and calligraphic inks, the works immediately evidence Barthes' love of stationery. They appear as experiments, as exercises, as developmental and as spontaneous; and crucially their status as drawings, paintings, doodles and writing remains open to interpretation. In his essay on the artist Bernard Réquichot, for example, he praises Réquichot's work as being 'amateur': 'He is *the one who does not exhibit,* the one who does not make himself heard. . . . the amateur seeks to produce only his own enjoyment (but nothing forbids it to become ours in addition, without his knowing it), and this enjoyment is shunted toward no hysteria' (Barthes 1985: 230). As discussed in the essay in this book, 'Works on Paper: The Drawings of Roland Barthes', the figure of the amateur is important as a means of countering power structures and keeping open to *writerly* pleasure. Barthes' practice of painting is arguably a means of setting aside (during the afternoons in which he would paint) the conditions, and conditioning, that come with being a writer.

A small proportion of Barthes' works on paper were exhibited as part of the *R-B: Roland Barthes* exhibition at the Centre Pompidou, in Paris (Alphant and Léger 2002). However, again, very little commentary accompanied them, and only a handful of other public displays have occurred outside of France. Notably, the drawings have never been shown nor discussed in the UK or USA, despite sustained interest in his writings – not least his writings on the visual arts (Barthes 1985). Of course, throughout his career, Barthes was concerned with the structures of language and writing. It is hardly surprising we find this preoccupation in his paintings. There is a way in which, perhaps, Barthes is unable *but to write,* even when holding a paintbrush in his hand.

Fifteen of Barthes' drawings were selected for the exhibition at the John Hansard Gallery (and reproduced in this volume). In each case, to varying degrees, you can see the mark-making is more that of a writer than an artist. He works on a size of paper suitable for working at a desk that would equally suit the writing of his critical texts. He rarely covers the paper as an artist might, the latter seeing the paper as a *support,* while Barthes perhaps cannot help but see the paper as a *sheet* upon which to write/ mark. Notably, however, Barthes does render a very deliberate and generous frame with the edges of the paper (though it is never drawn, but implied by the spacing of the mark-making). Overall, we might suggest the relationship between word/image, writing/painting is less consciously determined, but rather more imposed through body and gesture, through the notion of ductus (as Barthes refers to in his essays on Cy Twombly (Barthes 1985: 157–76, 177–94)) – which as a concept returns us to his very first book, *Writing Degree Zero* (1967), in which he identifies 'style' as something bound up with the body – in this case being the body of the writer.

Barthes' late writings from the 1970s onwards are an important guiding influence for how we might relate to the drawings. For his professorial inaugural lecture, at the Collège de France in 1977, when taking up a Chair in Literary Semiology, Barthes suggests the professor's 'sole activity here is research: to speak – I shall even say to dream his research aloud – not to judge, to give preference, to promote, to submit to controlled scholarship' (Barthes 2000: 458). As a counter to the structures of power, Barthes regards literature as a means to 'cheat with speech'. As he argued, this 'salutary trickery, this evasion, this grand imposture which allows us to understand speech *outside the bounds of power,* in the splendor of a permanent revolution of language, I for one call literature' (462). His reference to literature can surely be expanded to include the creative arts more broadly. Indeed, during this same lecture, Barthes marks a very important shift in his definition of the semiologist, whom he suggests needs to be 'an artist' playing with signs 'as with a conscious decoy, whose fascination he savours and wants to make others savour and understand'. The sign for this artist 'is always immediate, subject to the kind of evidence that leaps to the eyes, like a trigger of the imagination', which is why semiology in this case 'is not a hermeneutics: it paints more than it digs' (475).

The need to be *making marks* as a much as 'digging out' their meaning takes on further resonance when looking at Barthes' practice of painting. We begin to consider, for example, not just Barthes' conceptual interests and engagement with questions of temporality, but also spatial considerations, which in turn offers another reading of

Barthes' late texts. While Barthes is perhaps most often cited for his rumination on the temporality of the photograph (Barthes 1981), the late lecture courses give rise to an ethics not only of time, but also space. A figure repeated in both *How to Live Together* (2013a) and *The Neutral* (2005: 146), for example, is of a shoal of fish, as a pattern of fluidity preserving 'tactful' spaces between. As a formal consideration, this relates to the formal properties of Barthes' art practice. His paintings develop what we might refer to as a 'democracy of lines', with the relationship between figure and ground frequently blurred and whereby mark-making relates to the *spaces between* one and another mark rather than to space in relation to other marks. Space between marks, then, becomes a charged area of nearness that helps form a compositional whole of presence and absence. Barthes refers to the neutral as a transposing of structural concerns 'to the "ethical" level' (Barthes 2005: 7). His choice in pursuing a practice (and pleasure) of painting and drawing can arguably be understood as the means towards a de-structured space – both representationally and as a site of practice. Barthes once complained that in the cinema 'you are not permitted to close your eyes' (cited in Burgin 2011: 200) – it is a line Burgin evokes in relation to his inclusion of interstice material within his projections. We might consider the drawings produced by Barthes a place/space to inscribe his own associations: associations away from the usual structures of signification and power, somewhere where nothing happens.

/ Burgin

Victor Burgin came to prominence in the late 1960s as a conceptual artist, noted at the time as a political photographer of the left, and subsequently nominated for the Turner Prize. His entry into the nascent conceptual art domain signalled a continuation of a lesson learned from John Cage's handling of the disjuncture between absolute materiality and absolute idea. The combinatory and contradictory power of materiality and concept is a hallmark of Burgin's choice of media: photo-text works, prints, digital video and 3D modelling. Each medium becomes a vehicle for auto-inquiry into the materiality of the medium itself, which in turn refers us to both the materiality and conceptuality of memory, gender relations, and most especially space and place as sites for quotidian political analysis. As a thinker, Burgin has also pursued these concerns in a series of influential essays and books, drawing especially on the work of Barthes, Lacan and Foucault, among others. Widely respected as both an artist and a writer,

Burgin continues to hold an important place within visual arts scholarship.

His book *Thinking Photography* (1982) was a key text of its time. It went through ten reprints and remains an iconic volume. A similar trajectory awaited his work *The End of Art Theory: Criticism and Postmodernity* (1986). Burgin has continued to publish key works. *In/Different Spaces* (1996) is widely cited as an important text in the field of visual culture. In *The Remembered Film* (2004), Burgin works through a much-cited theoretical account of the moving image as occupying various physical and noetic spaces. *Components of a Practice* (2008) is a large-format book providing a rich retrospective of his work; and this is complemented by *Situational Aesthetics* (2009), which brings together key essays, combined with interviews and contemporary reflection on his work. Crucially, Burgin continues to make high calibre artworks, with significant recent commissions including: The University of Chicago (2015), the Museum fur Gegenwartkunst Siegen (2014), the Musée d'Art Moderne et Contemporain Geneva (2013, for the Wagner bicentennial), Istanbul 2010: Cultural Capital of Europe, among many others. He has had two recent shows in London, *Victor Burgin: On Paper* (2013), curated by David Campany; and a major exhibition, *A Sense of Place* (2013), curated by David Campany and Michael Maziere, in which five recent digital projection pieces are complemented by earlier photo-text works exploring relations between place, memory and image. The exhibition at the John Hansard has provided an occasion to screen recent projection works, most of which have not been shown previously in the UK or United States. Furthermore it has prompted the creation of a new work reflecting both on the history of the John Hansard Gallery (due to be vacated immediately after the show following a move to a new city-centre art space) and the broader influence of Barthes on his practice.

Victor Burgin's recent artistic output has largely consisted of installations of projected image loops. Often bespoke works about specific sites, these projection loops contain computer-generated imagery, analogue imagery, archival materials, film clip grabs, allusions, still photographs, probing cameras examining specific locales, landscapes or architectural structures, and eerie 'still moving' images in which part of the image remains utterly still while other elements within the same frame are animate and motile. The installations frequently contain other elements, e.g. spoken word, intertitles, textual installations on the walls, sound, music and strategic artistic use of the space of installation. They create a kind of 'psychical cubism' but with temporality. Acutely aware of the context of its engagement in a gallery or museum, Burgin constructs his loops in such a manner that viewers/listeners can and do enter

at any point in the projection and will likely stay until they have reached their point of entry, the 'reprise' operating as a kind of unfolding of the layers of the work. Often concerned with architecture, space, the built environment, memory and the means by which memory is physically and technologically constructed (via media and mediation), Burgin's recent digital projection installations might be considered as photographs that move (or 'still moving images'). Even that hybrid description does not do justice: these works are not video as such, nor photography tout court, but deliberate, painstaking constructions of viable techniques from available technologies. To describe them as digital is to curtail both the means employed and the results. However they are indeed projected, drawing attention to the space in which viewers engage these hybrid images and texts about other spaces. The circular or spiral nature of the image sequence and synched soundtrack demands that each element be synedochic or metonymic of the whole: a part of it but apart from it – the whole in the moment but also an individual temporality evocative in its own instant. Each element of these installations link to memory, projection, introspection and attentiveness, thus becoming means for exploring and evoking space, especially built environments no longer occupied or standing, as dwelling both in the present and absent. The return of the loop, or rather the return that is a loop, constitutes an epode of duration, layering and recycling. In important ways, Burgin's work is interested in the relationship between the unbuilt environment and the built environment, the clearing required to construct any structure. Returning to the play of materiality and psychological states, this clearing is equally true of the inner world of the viewing subject with the works evoking that which must be cleared in order to remember or engage a new experience.

In this book, a conversation between Ryan Bishop and Victor Burgin concentrates on two recent projection works of Burgin's *A Place to Read* (2010) and *Parzival* (2013), the former included in the Hansard Gallery show. The conversation is wide-ranging, taking on the genesis/commissions of each work, before discussing expanding conceptualisations of cameras and in-computer generation of images (moving and still) for gallery exhibition. The role of game engines in the creation of his recent projections then connects with his theoretical formulation of the 'cinematic heterotopia', which invokes spatial and temporal imaginaries as well as the technological apparatuses that have helped produce them. The specificity of the viewing situation in a gallery, as opposed to the cinema, leads to a discussion of the loop as a structure for such installations as well to thoughts about word/text and image relationships. Throughout the entire conversation, the issues of place, memory, history, loss, spatial politics and

justice provide larger frameworks for the specific concerns addressed.

The first work discussed was commissioned for the 'Lives and Works in Istanbul' project undertaken during that city's designation as the 'European Cultural Capital' in 2010. The work he produced when living in the city, *Bir okuma yeri / A Place to Read,* is a digital text-image projection. The piece is silent with text presented on the walls of the gallery (or inserted as intertitles depending on the venue) and involves a film loop shifting between black and white and colour imagery. Created using virtual camera technology, the loop deftly and hauntingly weaves imagery of a coffee house from Istanbul's past, reconstituting it in the present as a form of visual memory. Reminiscent of the Alain Resnais/Chris Marker film *Nuit et brouillard (Night and Fog),* from 1955, the projection's tracking camera searches empty structures for signs of human presence beyond the built environment. The other projection work discussed is *Parzival* (2013), commissioned by the Musée d'Art Moderne et Contemporain, Geneva for the bicentennial of the birth of Richard Wagner and installed at the Geneva Wagner Festival. The installation is a complex layering of animated stills, generated landscapes, intertitles, wall texts and film allusion, with various intertextual dimensions, including Rossellini's *Germany Year Zero,* an aria from the opera and indirect allusions to the thirteenth-century chivalric romance it sprang from, all of which add up to a 'representation of a psychological object' (Burgin 2014: 59). The wall texts provide counterpoint to the projection and soundtrack, containing translations of portions of the opera sung on the soundtrack, quotations from Milan Kundera and Philip K. Dick, letters by Wagner about the opera's gestation, letters from his time in Venice when working up the ideas of the piece and including dreams, notes on various productions and stagings, and reception of Wagner generally. The conversation explores how the range of textual sources 'ground' the work spatially and temporally.

Underlying much of Burgin's work is the handling of still images, or rather what he refers to as the sequence-image (Burgin 2004), which is neither strictly 'image' nor 'image sequence', but an element of remembered film of such brevity they might almost be stills. He writes, for example, of how 'a concatenation of images raises itself, as if in bas relief, above the instantly fading, then forgotten, desultory thoughts and impressions passing through my mind' (Burgin 2004: 21). If one considers the title of Derrida's book on photography, *Athens, Still Remains* (2010), or Beckett's last prose work published in his lifetime, *Stirrings Still* (1988), the productive ambiguity of 'still' comes to the fore: evoking a condition or situation in which activity ceases but duration occurs in spite of, or perhaps through, this cessation. With the Derrida title,

the photographs provide still remains themselves of still remains of the city's recent and ancient past, proving that Athens continues (or remains) through that which no longer moves (is still). Beckett's title proves more intriguing, for the stirrings have started to slow if not stop if read one way; if read another, the continuity of still – its durational dimension – means that the stirrings continue to stir. Their transitivity, however, remains a further mystery. Similarly, when viewing the projection works by Burgin, such as *A Place to Read*, and *Prairie* (2015) and *Belledonne* (2016), as shown at the John Hansard Gallery, there is both a stirring and stillness to the handling of past remains, dominant and counter narratives and the fleeting recuperation of images and memories. Perhaps we might also consider Barthes' works on paper as opening out to stillness, although in this case leading to the effacing of narrative and representation. In the chapter, 'Works on Paper', it is suggested we consider the drawings a form of exercise *away from* writing – a means of bringing signification to a standstill, while *still* allowing the play of the very mark-making required before meaning can take hold: the clearing required before structure can emerge.

/

In turning to the specific curatorial rationale for displaying the recent and newly commissioned projection works by Burgin alongside Barthes' works on paper, a number of compositional and conceptual considerations are at play. An underlying connection is of course both Barthes' and Burgin's reading and *writing* of Text and image-text. Specific themes are explored in 'Reading Barthes', which provides a correspondence with Burgin on this first encounter and subsequent 'reading' of Barthes from the 1960s through to the present. This entry provides an opportunity for Burgin to reflect upon his previous interest in Barthes' writings and his own re-workings of those writings in both his practice and in his essays – notably 'Diderot, Barthes and *Vertigo*' (Burgin 1986: 112–39) and 'Barthes' Discretion' (Burgin 2004: 29–43).

Another important curatorial element for the exhibition, as well as this book, resides curiously enough in the slash that Barthes so relished and which creates and embodies intellectual, conceptual and material relationships. Also known as the *barre oblique,* the slash is a rather impolite intruder in formal writing, with prescriptive manuals advising one to steer clear of it. (Its appeal for Barthes becomes immediately apparent.) The slash as a punctuation mark, a chirographic mark, performs several functions,

meaning potentially 'and', 'or', or both at the same time: the very unambiguous mark of ambiguity. The slash can also stand in for the Latin preposition *cum,* which variously means 'combined with' or 'used as' or 'additionally being', as in author/ artist. This humble mark contains simultaneously spatial, temporal and conceptual qualities. It brings together by dividing and keeping separate, or brings to together to be viewed and considered together, two concepts (signs) that are held apart through the mark that joins them. Thus the slash functions much in the way the signifier is divided from the signified, only to be unified in the sign through the slash. It is the *gramma,* which in Greek means 'mark' or 'cut', and thus evokes much for Barthes as prolific mark-maker and Burgin as inventive cutter (and linker) of concepts and images. Constitutive of division, our simple chirographic mark serves essentially as 'visual onomatopoeia' for the act of mark-making generally.

Burgin's projection works, in their combinatory movement, borrow the cinematic grammar of the slash, with cuts that divide and suture simultaneously by bringing together and juxtaposing disparate materials that go towards the formation of a whole. Burgin's slashes call to mind Eisenstein's montage, Abel Gance's visual experimentation and Pound's imagism, among other allusive echoes. In French, the cinematic cut is called a *coup,* which means a hit or a blow. As with the slash on the printed page, it is a cut or hit that makes and leaves a mark. With Burgin's works, the visual slash is a very knowing one, one steeped in cinematic and moving image history. Burgin often quotes the line from Barthes invoked earlier that asserts you cannot close your eyes at the cinema. However a sequence that visually asserts almost the opposite of Barthes' point – indeed one of the most famous sets of cuts in cinematic history – can be found in Luis Buñuel and Salvador Dali's *Un chien andalou* (1929). The dream-like power of the cut that the Surrealists relished so much is on full display in the sequence at the start of the film. When the sliver of cloud slices the moon and the film cuts to a close-up of a straight razor slicing a gelatinous organic eye, it is no longer the case that you cannot close your eyes at the cinema; it is that your eyes have been closed for you *by* cinema. You cannot close your eyes at the cinema because cinema has already sliced them: your eyes are gone; you have none to open or close. Burgin's projection slashes knowingly evoke simultaneously and in tension the concerns operative in Barthes as well as Buñuel and Dali.

On first viewing, Barthes' drawings appear very different to those works shown by Burgin. Barthes' works are gestural, colourful, 2D and contained (having been made sitting at a writing desk). Yet both Barthes and Burgin share an interrogation of

frame (of power structures, of systems of representation, of language and pictures, of physical and psychical constraints). In *Components of a Practice* (2008), Burgin refers to composition as 'the corollary of framing', against which he refers to his work (which draws upon a 'panoramic scanning of the image') as 'acompositional', by which he means 'the contents of the moving frame are in a perpetual state of *de*-composition' (Burgin 2008: 92). While Burgin's work utilises precise methods to achieve this state of de-composition, Barthes' works on paper present themselves in their own state of de-composition. For example, as mentioned earlier, Barthes repeatedly renders a very deliberate and generous frame with the edges of the paper, borders gestured to but never explicitly drawn except through the absence or spacing of the mark-making. We are left wondering whether the border emerges or is carefully staged throughout the process of drawing. Furthermore, just as Burgin eschews a parallax view in his panoramic works, which means 'there is no differential movement between foreground, middle-distance and background' (92), Barthes' undercuts any clear sense of figure and ground. As we look at the works as de-compositional, we find it hard to determine their specificity. Overall, a consideration of spaces and frames (and their alternative alignments or decomposition) is common to both Barthes and Burgin – notably for example in their respective essays 'Diderot, Brecht, Eisenstein' (Barthes 1985: 89–97) and 'Diderot, Barthes, *Vertigo*' (Burgin 1986: 112–39); but also Barthes' early essay 'The World as Object' (Barthes 2000: 62–73), which draws out an 'aesthetic of silence' pertinent to Burgin's *A Place to Read.* Underlying the thinking of both Barthes and Burgin – and seen with the works displayed for *Barthes / Burgin* – is an expansive notion of the Text (or the 'enormous Text' as Barthes refers to it in an essay on Réquichot). The Text is of course a concept Barthes is greatly associated with 'authoring', and which Burgin has extended and tested through both his art practice and writing. In walking through the gallery spaces of the John Hansard we can move – back and forth – from the virtual heterotopia and visual archaeologies of Burgin's projections to Barthes' works on paper hung upon the wall. These 'squandered' pieces of paper are physical remnants from the 1970s. They are transported from a very particular intellectual milieu, in which the Text was both theorised and made manifest, giving rise to a 'way of seeing' that is both realised and unsettled as we return again into the remembered films of Victor Burgin. Between these works, then, we are presented with sequence-images, with a *barre oblique,* a cut and a join. . .

References

Alphant, Marianne and Léger, Nathalie (ed.) (2002) *R-B Roland Barthes : exposition présentée au centre Pompidou, galerie 2, 27 novembre 2002–10 mars 2003*. Paris: Seuil / Centre Pompidou / IMEC.

Badmington, Neil (2015) *'Fiches and Biographemes'*, Times Literary Supplement, 12 June 2015, pp. 17–18.

Barthes, Roland (1967) *Writing Degree Zero*, trans. by Annette Lavers and Colin Smith. London: Jonathan Cape.

Barthes, Roland (1974) *S/Z*, trans. by Richard Howard. New York: Hill and Wang.

Barthes, Roland (1977) *Roland Barthes*, trans. by Richard Howard. Berkeley: University of California Press.

Barthes, Roland (1978) *A Lover's Discourse*, trans. by Richard Howard. New York: Farrar, Straus and Giroux.

Barthes, Roland (1981) *Camera Lucida: Reflections on Photography*, trans. by Richard Howard. New York: Hall and Wang.

Barthes, Roland (1985) *The Responsibility of Forms: Critical Essays on Music, Art, and Representation*, trans. by Richard Howard. New York: Hill and Wang.

Barthes, Roland (2000) *A Barthes Reader*, ed. by Susan Sontag. London: Vintage.

Barthes, Roland (2005) *The Neutral: Lecture Course at the Collège de France (1977–1978)*, trans. by Rosalind E. Krauss and Denis Hollier. New York: Columbia University Press.

Barthes, Roland (2009) *Mythologies* (originally published 1957), rev. edn. trans. by Annette Lavers. London: Vintage.

Barthes, Roland (2011) *The Preparation of the Novel: Lecture Courses and Seminars at the Collège de France, 1978–1979 and 1979–1980*, trans. by Kate Briggs. New York: Columbia University Press.

Barthes, Roland (2012) *Mourning Diary: October 26, 1977 - September 15, 1979*, trans. by Richard Howard. New York: Hill and Wang.

Barthes, Roland (2013a) *How to Live Together: Novelistic Simulations of Some Everyday Spaces*, trans. by Kate Briggs. New York: Columbia University Press.

Barthes, Roland (2013b) *Travels in China*, trans. by Andrew Brown. Cambridge: Polity Press.

Barthes, Roland (2015a) *Album: Inédits, correspondences et varia*, ed. by Éric Marty. Paris: Seuil.

Barthes, Roland (2015b) *La Préparation du roman: Cours au Collège de France (1978–1979 et 1979–1980)*, ed. by Éric Marty. Paris: Seuil.

Barthes, Roland (2015c) *L'Empire des signes*. Paris: Seuil.

Batchen, Geoffrey (ed.) (2009) *Photography Degree Zero: Reflections on Roland Barthes's Camera Lucida*. Cambridge, MA: MIT Press.

Beckett, Samuel (1988) *Stirrings Still*. London: Calder.

Burgin, Victor (ed.) (1982) *Thinking Photography*. London: Macmillan

Burgin, Victor (1986) *The End of Art Theory: Criticism and Postmodernity.* London: Palgrave

Burgin, Victor (1996) *In/Different Spaces: Place and Memory in Visual Culture.* Berkeley and London: University of California Press.

Burgin, Victor (2004) *The Remembered Film.* London: Reaktion Books.

Burgin, Victor (2008) *Components of a Practice.* Milan: Skira.

Burgin, Victor (2009) *Situational Aesthetics,* ed. by Alexander Streitberger. Leuven: Leuven University Press.

Burgin, Victor (2011) *Parallel Texts: Interviews and Interventions about Art.* London: Reaktion Books.

Burgin, Victor (2014) *Five Pieces for Projection.* Berlin: Sternberg Press.

Derrida, Jacques (2010) *Athens, Still Remains,* trans. by Pascale-Anne Brault and Michael Naas. New York: Fordham University Press.

Lorent, Fanny (2015) *Barthes et Robbe-Grillet: Un dialogue critique.* Bruxelles: Impressions nouvelles.

Nachtergael, Magali (2015) *Roland Barthes contemporain.* Paris: Max Milo.

Samoyault, Tiphanie (2015) *Roland Barthes.* Paris: Seuil.

Sollers, Phillipe (2015) *L'Amitié de Roland Barthes.* Paris: Seuil.

Thomas, Chantal (2015) *Pour Roland Barthes.* Paris: Seuil.

Works on Paper by Roland Barthes

Editors' Note

The Manuscripts Department at the Bibliothèque nationale de France hold a large collection of Roland Barthes' personal notes and handwritten manuscripts. In amongst these are three archival boxes containing over 300 of his drawings. A selection of 15 drawings were kindly loaned for display in the UK for the first time, to be part of the exhibition, *Barthes / Burgin*, shown at the John Hansard Gallery. The selection of the drawings plays along three themes: the signifier without signified; de-composition; and neutral specificity.

Throughout his career, Barthes was concerned with the structures of language and writing and many of the artworks show an oscillation between script and painting. Sometimes this is an explicit display, as with the work reproduced at the end of his autobiography, which he describes as 'the signifier without the signified (see No. 218, on p.29)'. Making use of a range of mediums, from oils and acrylics to felt-tip pens and calligraphic inks, the drawings appear as experiments, and as being spontaneous, yet each one is carefully numbered. In *Components of a Practice,* Victor Burgin refers to composition as 'the corollary of framing', against which he describes his work as 'acompositional', whereby 'the contents of the moving frame are in a perpetual state of de-composition'. Barthes' works on paper present themselves in their own state of de-composition. For example, Barthes repeatedly renders a very deliberate and generous frame with the edges of the paper, yet this is never drawn but implied by the spacing of the mark making. He also undercuts any clear sense of figure and ground. Overall, the approach to painting and drawing suggests of an on-going exercise, repetitiveness, or meditation. Barthes develops what we might call a 'democracy of lines', whereby mark making relates to space *between* one and another rather than space in relation to another. We can understand his approach in relation to his interest in the Neutral, which he refers to as a transposing of structural concerns to an ethical level. His choice in pursuing a practice (and *pleasure*) of painting and drawing can arguably be understood as the means towards a de-structured space – both representationally and as a site of practice.

The Signifier without Signified

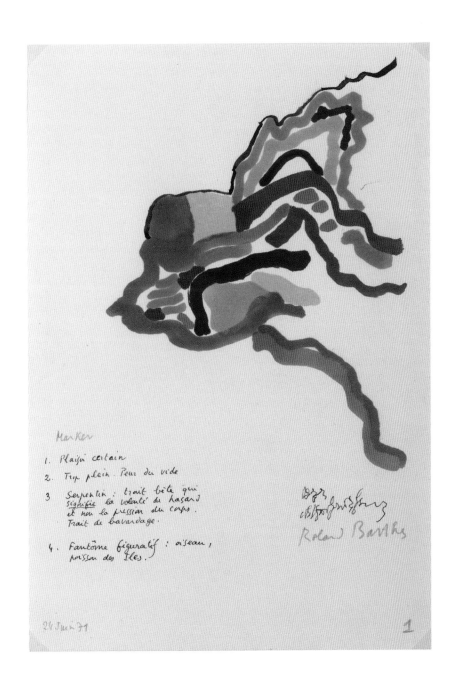

Marker

1. Plaisir certain

2. Trop plein. Peur du vide

3 Serpentin : trait bête qui
 signifie la volonté du hasard
 et non la pression du corps.
 Trait de bavardage.

4. Fantôme figuratif : oiseau,
 poisson des Îles.

Roland Barthes

24 Juin 71 1

No. 1, 24 Juin 71 (26.8 x 18.5 cm)

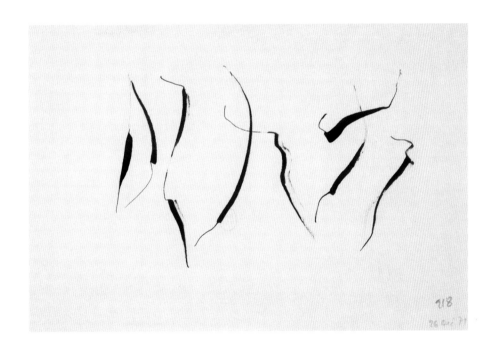

No. 218, 26 Dec 71 (16 x 23.3 cm)

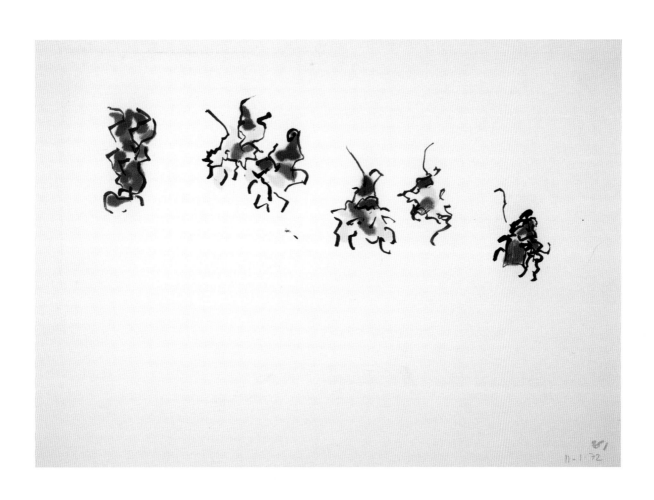

No. 261, 11.1.72 (26.2 x 36.7 cm)

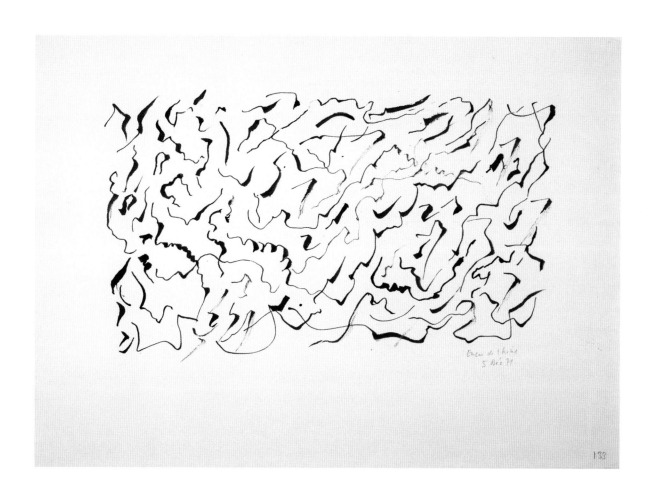

133

No. 133, 5 Dec 71 (26.2 x 36.7 cm)

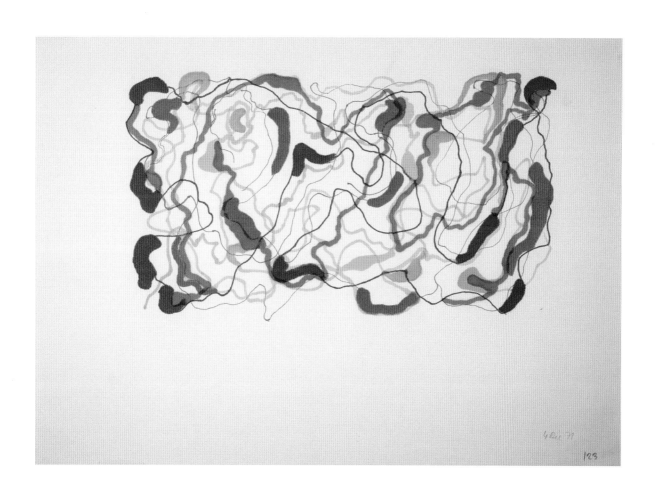

No. 123, 4 Dec 71 (29.4 x 41.5 cm)

De-composition

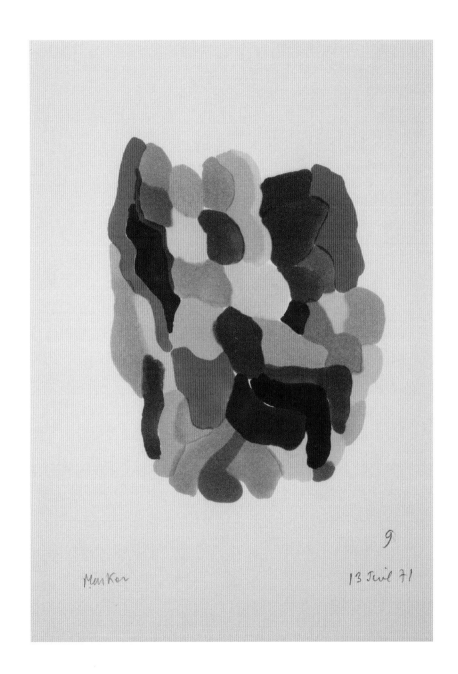

Marker

9

13 Juil 71

No. 9, 13 Juil 71 (26.1 x 18.1 cm)

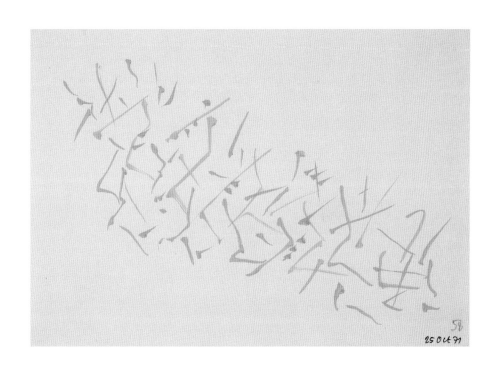

No. 58, 25 Oct 71 (15.8 x 22.4 cm)

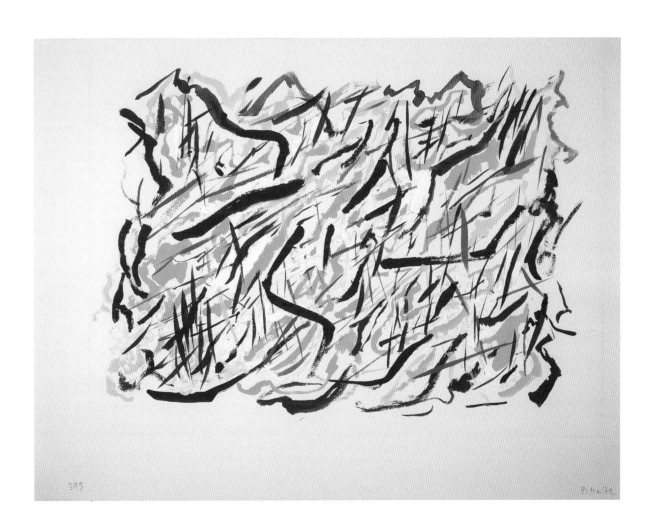

No. 393, 21 Mai 72 (30.1 x 39.4 cm)

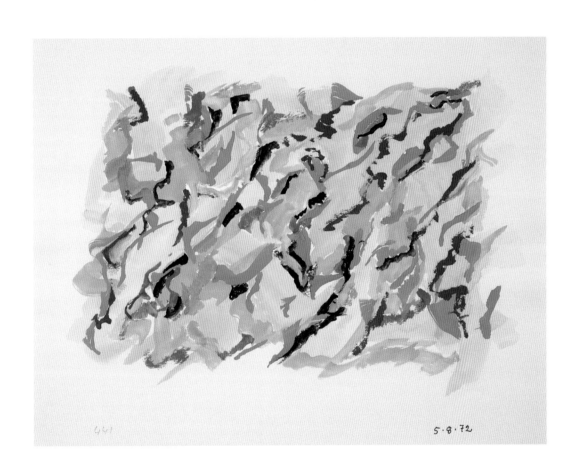

No. 441, 5.8.72 (23 x 30.2 cm)

Neutral Specificity

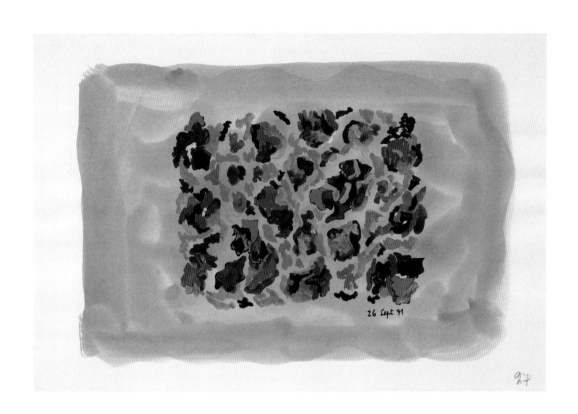

No. 27, 26 Sept 71 (17.5 x 26 cm)

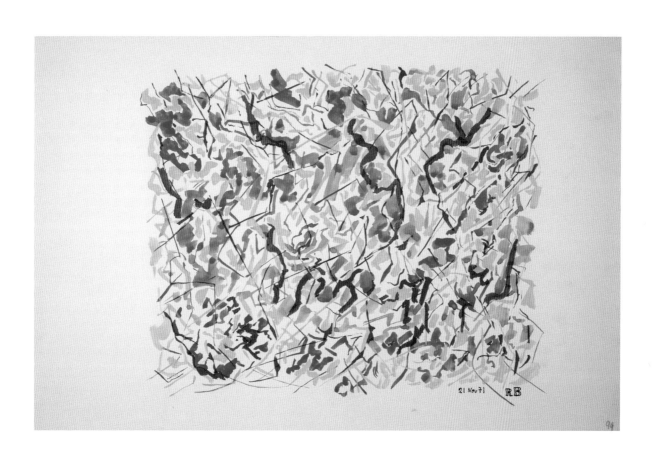

No. 99, 21 Nov 71 (28.7 x 43.2 cm)

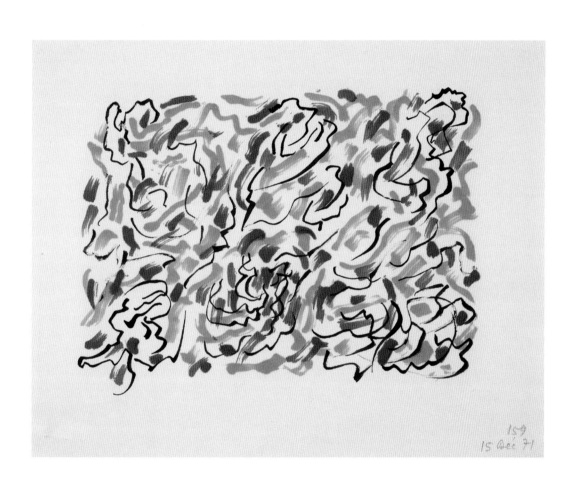

No. 159, 15 Dec 71 (20.8 x 26.2 cm)

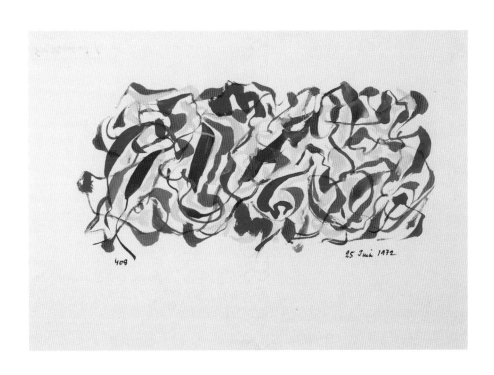

No. 408, 25 Juin 1972 (15.8 x 22.4 cm)

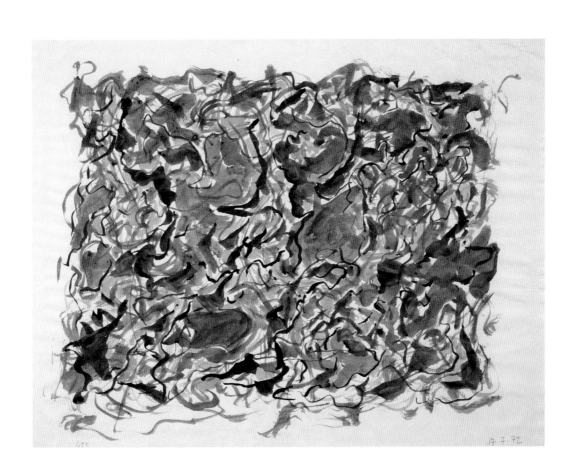

No. 425, 17.7.72 (25.3 x 32.9 cm)

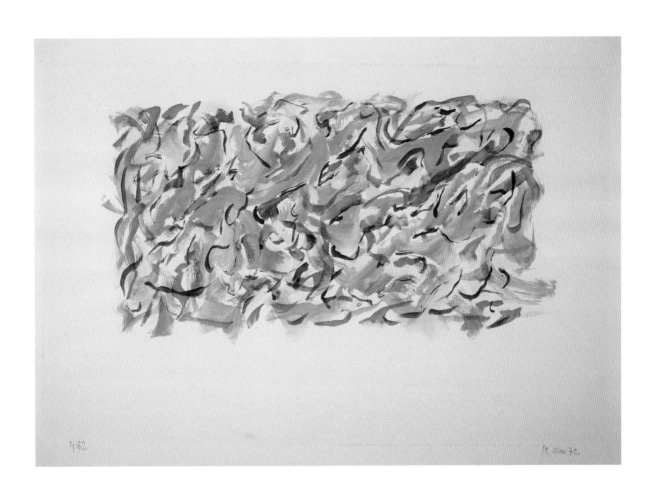

482

12 nov 72

No. 482, 12 Nov 72 (29.6 x 41.7 cm)

An Exercise in Drawing

Sunil Manghani

> I often switch from one pen to another just for the pleasure of it. I try out new ones. I have far too many pens – I don't know what to do with all of them! (Barthes 1985a: 178)

Barthes' love of stationery is reasonably well known. In an interview in *Le Monde* in 1973, he speaks of his 'almost obsessive' relationship to pens and inks (Barthes 1985a: 177–82). He is particularly enamoured with felt-tip pens, for example, which had started to appear in shops at the time. As an aside he admits the 'fact that they were originally from Japan was not . . . displeasing' (178). Indeed, Barthes recounts the pleasures of Japanese stationery in a dedicated entry in *Empire of Signs* (1982). 'The object of the Japanese stationery store', he writes, 'is that ideographic writing which to our eyes seems to derive from painting' (1982: 85–6). He is particularly interested in the graphism of Japanese writing, which he romanticises to suggest of a fluid, fragile writing borne of an array of delicate stationery:

> Everything, in the instrumentation, is directed toward the paradox of an irreversible and fragile writing, which is simultaneously, contradictorily, incision and glissade; papers of a thousand kinds, many of which hint, in their texture powdered with pale straws, with crushed stems, at their fibrous origin; notebooks whose pages are folded double, like those of a book which has not been cut so that writing moves across a luxury of surfaces and never runs [. . .] As for the brush (passed across a faintly moistened inkstone), it has its gestures, as if it were the finger; but whereas our old pens knew only clogging or loosening and could only, moreover, scratch the paper always in the same direction, the brush can slide, twist, lift off, the stroke being made, so to speak, in the volume of air; it has the carnal, lubrified flexibility of the hand. (Barthes 1982: 86)

In the pursuit of his own writing, Barthes always returned 'to fine fountain pens. The essential thing is that they can produce that soft, smooth writing I absolutely require'

(1985a: 178). He explains a necessary two-step process to his writing:

> In my case, there are two stages in the creative process. First comes the moment when desire is invested in a graphic impulse, producing a calligraphical object. Then there is the critical moment when this object is prepared for the anonymous and collective consumption of others through transformation into a typographical object . . . In other words – first I write the text with a pen, then I type the whole thing on a typewriter . . . (1985a: 179)

Interestingly, for all the insight we have into Barthes' love of writing as a physical, practical engagement with ink and paper (Badmington 2008), what is far less remarked upon, is that Barthes sustained a practice of drawing and painting throughout the 1970s. A large collection of his artworks are held in Paris at the Bibliothèque nationale de France (BnF). There are said to be some 700 works in existence (Clerc 2011), with the BnF holding around 300. They are kept in three large, plain archive boxes. Box 1 contains works exclusively from 1971. In boxes 2 and 3 there are works ranging from 1972 through 1978 (though not many examples of the latter half of the 1970s). Barthes was known to give individual drawings away to friends and family, often as cards or gifts. There are a few examples held at the BnF of pieces that had seemingly been prepared as cards or framed in readiness to give away. It is likely that various drawings are in the possession of individuals, but it would still suggest a larger collection is held somewhere else (likely with Barthes' younger brother).

In opening the boxes at the BnF you immediately get a sense of scale and volume. The works are loosely filed in bundles (held in grey, A2 dossier folders), with many individually wrapped in tissue paper. The works can easily be picked up by hand. They range from very small pieces of paper through to larger pieces closer to A3 and even in a few cases A2 sheets. However, the vast majority are made on paper we would generally associate with writing – in fact there are a few examples of paintings on college letter-headed paper. He would appear to utilise whatever paper he had to hand (perhaps being less obsessive about paper than he was about pens, inks and brushes). Barthes would sit to paint, using paper always of a scale convenient to working on the flat or slightly inclined surface of a small table or desk. It was an activity not far removed from writing. Among the collection of photographs at the start of *Roland Barthes* (1977a), a set of three show him working at a desk or table. In caption to these photographs, he writes: 'My body is free of its image-repertoire only when it establishes

its work space. This space is the same everywhere, patiently adapted to the pleasure of painting, writing, sorting' (1977a: np). Barthes does indeed appear content and at ease in these pictures, one of which, specifically, shows him at his painting table. He is seated in a low-back chair, with all that he needs neatly surrounding him. This is not the image of a muscular, vital artist, but rather a quiet, gentle dabbler of paints. Barthes is at peace with himself, lost even to the cares of the world, consumed in an activity without goals, without audience.

Despite having produced many hundreds of drawings over a decade, there is very little variation. Again and again, we see the same tentative, weaving lines of colour. He would restrict his palette to three or four colours and build up a collection of lines and marks. Some items show a deliberate play between writing and drawing. We might think of Paul Klee's incorporation of letter-like and ideogrammic figures in many of his painting, a notable example being *Geheime Schriftzeichen* [Secret Letters] from 1937. Two specific examples of Barthes' works, held at the BnF, deliberately play with invented letters, spaced out very similarly to Klee's work. One of these by Barthes is dated 14 November 1971, the other 22 July 1972. The former is used on the cover of a catalogue, *Carte Segni* (Barthes 1981), which was published in conjunction with an exhibition of the drawings in Italy; the only exhibition to be arranged in Barthes' lifetime, and which sadly he never got to attend due to his death not long before. The majority of Barthes' drawings are made of many undulating and interlaced lines, suggestive of a mixed-up bundle of long unfurled lines of writing and, in places, are reminiscent of Asian calligraphy and brushwork. There are echoes of the work of artists such as Mark Tobey and John Lantham (particularly his one second drawings), as well as Simon Hantaï's early paintings incorporating writing, notably *Peinture (Ecriture Rose)* (1958–59). Bernard Réquichot's paintings of illegible writing, André Masson's automatic drawing and Cy Twombly's allusive writing/drawing are each pertinent reference points, and indeed Barthes wrote key essays on each of these artists (1985b: 153–6, 157–76 and 207–42 on Masson, Twombly and Réquichot respectively). A further point of reference is the poet Henri Michaux, whose strange ink marks/characters offer a visceral consideration of the relationship between word and image. However, it would be wrong to make direct comparisons. Barthes is by no means an artist in the sense we would attribute to these aforementioned names. He does not relate to the canvas (or paper) as a support for a work in the way an exhibiting artist does; his mark-making does not portray the confidence of a painter, but instead betrays the gesture of a writer, bound by the paper and its margins, albeit free in this case to

scribble, to 'write' in free form, without form.

It is also worth noting that among the holdings at the BnF are numerous sketches by Barthes that relate directly to Japanese ink painting and calligraphy (in a few cases deliberate attempts to copy from known woodblock prints), and also a series of two- or three-tone compositions with formations akin to the Japanese rock garden (see No. 27, on p. 45). In *Empire of Signs,* Barthes reproduces a combined haiku and haiga painting by Yoko Yayu (1702–83). The scroll of paper presents a haiku written in 'dancing' Japanese handwriting. It is a poem about mushroom picking, which is underscored by a flourishing line drawn *alla prima* that we are told is a 'wisp of straw, on which they string the mushrooms' (1982: ix). The pleasure in seeing this work for Barthes stems in part from the fact that he is unable to read the Japanese characters. The illustration is captioned in the book with two simple questions: 'Where does the writing begin? / Where does the painting begin?' (1982: 21). When leafing through the many sheets of paper stowed in the archive boxes at the BnF, what becomes apparent is the same ongoing fascination with the beginnings of both writing and painting. Thus, while the drawings are made up merely of irregular interconnections of marks, colour and line, what emerges from this iterative process is Barthes' engagement with the spatial properties of writing, over and above any signification.

It is difficult to know whether to refer to them as drawings or paintings. Barthes would appear to query this himself in a brief note published in *Les Nouvelles Littéraires* in 1978 (this entry is one of several responses from a survey of writers on their practice of drawing and painting). A difficulty emerges as soon as he reaches for a description of his hobby. Is it drawing, painting or graphics, he wonders, or rather perhaps simply 'colouring' or graffiti (Barthes 1978). The phrase 'works on paper' is perhaps one way of capturing all of these activities, but it can be unwieldy in general conversation (and we must be wary of elevating them as Works, not least given Barthes' belief in the pleasures of the Text). The references here to 'paintings' and 'drawings' are used somewhat interchangeably, sometimes one is used instead of the other simply because a specific work is in mind, which depending on the exact medium likely evokes one term over another. But in the main either term is to be understood to evoke numerous possibilities: They are drawings in that they are works on paper made on the flat surface and feel best in one's hand or viewed horizontally. Drawings in that they are mainly formed of lines. Yet painterly too, with an eclectic use of inks, acrylics, felt pens and pastels. The colours – or indeed colourings – bear instances of blending, of collision. Through this 'medium' their composition forms. Taking Walter Benjamin's

(2004) cue, a drawing is inseparably linked to its background, whereas painting has no background (or fills it entirely). For Benjamin, painting is a 'medium', whereby 'no one color [is] ever superimposed on another, but at most appear in the medium of another colour' (Benjamin 2004: 85). The further significance of Benjamin's account is his distinction between sign and mark: 'the sign is printed on something whereas the mark emerges from it', or 'signs are intentionally made by a subject whereas marks just emerge or appear' (84). We could easily argue about these terms, but Benjamin's account at least reminds us of certain differences at stake between drawing, painting and writing – differences that Barthes would have certainly appreciated, and indeed continually fascinated him.

Three Possible Accounts

> If I were a painter, I should paint only colors: his field seems to me freed of both the Law (no Imitation, no Analogy) and Nature (for after all, do not all the colors in Nature come from the painters?) (Barthes 1977a: 143)

There is a way in which Barthes the 'painter' is only ever a contingent, imagined possibility. Barthes often writes within a trope of 'as if'; which he refers to in his lecture on Proust: 'It is important for me to act *as if* I were to write . . . [. . .] "As if": is not this formula the very expression of scientific procedure, as we see it in mathematics? I venture a hypothesis and I explore, I discover the wealth of what follows from it; I postulate a novel to be written, whereby I can expect to learn more about the novel than by merely considering it as object already written by others' (Barthes 1989: 289-90). Importantly, in this essay, Barthes remarks upon a shift to making: 'I put myself in the position of the subject who *makes* something, and no longer of the subject who speaks *about* something: I am not studying a product, I assume a production' (289). With these remarks in mind, it is possible to posit at least three accounts of Barthes' creative engagement with drawing and painting. Firstly, we might say he is a writer who happened to dabble in painting. Barthes himself gives us the cue to this kind of reading. He makes frequent reference to the figure of the amateur (not least in the aforementioned essay on Proust). It appeals to him as a way to destabilise hierarchy. But also, there is an important idea about doing something for the 'love' of it. The amateur is a figure that connects with *The Pleasure of the Text* (1975), but equally

stems back to *Mythologies* (2009 [1957]). Like the 'reader of signs' (unlike the producer and critic of signs), Barthes the painter is someone simply consumed by the act of mark-making. Secondly, however, we could suppose Barthes is a writer who also has a visual practice. The sheer volume of the drawings and their consistent approach might lead us to this view. Stephen Ungar (1983: 85) suggests that the exhibition of Barthes' paintings and sketches in 1981 (at the Casino dell'Aurora in Rome) is 'the culmination of a creative activity Barthes acknowledged openly in the interplay between word and image evident throughout the photos, sketches, and fragments of the *Roland Barthes'*. Thirdly, we can consider the drawings a part of Barthes' practice of Writing (understood in an expanded sense). In this case, as examined below, we can look towards the late lecture courses for some navigation (Barthes 2005; 2013). In an entry on colour in his lectures on the Neutral, for example, he notes how 'the Neutral is difficult, provocative, scandalous: because it implies a thought of the indistinct, the temptation of the ultimate (or the ur) paradigm: that of the distinct and the indistinct' (Barthes 2005: 51).

The Amateur

> The amateur (someone who engages in painting, music, sport, science, without the spirit of mastery or competition), the Amateur renews his pleasure (*amator:* one who loves and loves again); he is anything but a hero (of creation, of performance); he establishes himself *graciously* (for nothing) in the signifier: in this immediately definitive substance of music, of painting; his praxis, usually, involves no *rubato* (the theft of the object for the sake of the attribute); he is – he will be perhaps – the counter-bourgeois artist. (Barthes 1977a: 52)

Barthes explicitly describes his own activity of painting as 'marginal', as a hobby *(violon d'Ingres)*, citing the painter J.D. Ingres who famously played a violin as a hobby (Barthes 2005: 140). Interestingly, Steven Ungar (1983: 85) has framed Barthes' submerged artistic activity in terms of a 'discourse of a frustrated artist', as if Barthes felt he had to make a trade-off between art practice and writing. This, however, seems at odds with Barthes' more modest partaking of pleasure through painting. Also there are no real indications that Barthes considered painting a 'serious' endeavour. Instead, he would more likely argue he took *pleasure* in painting; he was an Amateur (with a capital 'A').

The figure of the Amateur is evoked in Barthes' (1985b: 207-42) commentary on the artist Bernard Réquichot: 'He is *the one who does not exhibit,* the one who does not make himself heard. . . . the amateur seeks to produce only his own enjoyment (but nothing forbids it to become ours *in addition,* without his knowing it), and this enjoyment is shunted toward no hysteria' (230). This lengthy article, 'Réquichot and His Body', was published in the same year as *The Pleasure of the Text* (1975). Barthes ends the piece with a flourish reminiscent of 'From Work to Text' (1977b: 155-64): 'To recognize Réquichot's signature is not to admit him to the cultural pantheon of painters, it is to possess *an additional sign in the chaos of the enormous Text* which is written without interruptions, without origin, and without end' (1985b: 236; emphasis added). As a way of understanding Barthes' approach to painting, it is worth keeping open to this idea of the 'enormous Text'; as going beyond the tyranny of language, and which is accessed through what one writes (and draws), not what one thinks (cf. Badmington 2008: 90). Something that perhaps the Amateur is particularly well disposed towards.

A Visual Practice, or Technology of the Self

Being a hedonist (since he regards himself as one), he seeks a state which is, really, comfort; but this comfort is more complicated than the household kind whose elements are determined by our society: it is a comfort he arranges for himself [. . .] This personal comfort might be called: *ease.* Ease can be given a theoretical dignity ('We need not keep our distance with regard to formalism, merely our ease'), and also an ethical force: it is the deliberate loss of all heroism, *even in pleasure.* (Barthes 1977a: 43–4)

It is worth noting that Barthes was a man of regular habits, which in itself might lead us to consider him a practitioner; as someone who practises through repetition. In turn, as discussed below, such a 'practice' resonates with Michel Foucault's account of 'technologies of the self' (Foucault 1988). Barthes drew in the afternoons, in between writing and mainly in the vacation periods that allowed for a regular routine. The simplicity of the drawings and the lack of deviation suggest less an exploration *in* drawing, more an exercise *of* drawing. This sense of 'exercise' can be developed in two ways: firstly, in terms of drawing as a 'practice' of structures, and secondly, in

terms of technologies of the self.

Marion Milner's *On Not Being Able to Paint* (1986) offers a useful counter example to Barthes' practice of drawing. What comes across in her account is of drawing being in the service of the exploration of ideas. However, one key finding is the instability of line and outline: 'When really looked at in relation to each other their outlines were not clear and compact, as I have always supposed them to be, they continually become lost in shadow' (Milner 1986: 15). This leads her to question: why such 'a *great mental effort* [was] necessary in order to see the edges of objects as they actually show themselves rather than as [she] had always thought of them' (15). This 'great mental effort' might be framed in terms of semiotics. General discourse allows for the 'edges' or distinctions of objects to be delineated. It is only when we come to the 'language' of painting and drawing (as with literature and other art forms) that things start to unravel – we begin to approach the 'enormous Text'. A link can be made to Henri Michaux, who writes:

> One does not come across unfinished languages – half-fashioned, abandoned midway (or sooner). / Yet how many fore-languages there must have been, left behind, never to be known. (Michaux 2006: np)

While languages may not be left unfinished, we do allow for unfinished drawings (one only needs to think of the artist sketchbook and preparatory drawings). In his essay 'Erté, or À la lettre' (1985b: 103–28), Barthes describes his frustration when typing, unable to keep from making the following mistakes:

> sturcture
> susbtitute
> trasncription

'Each of these mistakes,' he writes, 'takes on a bizarre physiognomy, personal and malevolent' (1985b: 119–20). Of course, with predictive and auto-correcting typing the above words are actually rather difficult to type up (in)correctly. Although, equally, auto-correction allows one to conjure the very sentence you imagine without typing all of the right keys. Thus making *sturcture* and *structure* indistinguishable. Barthes would surely lament such a condition. His visual practice is about allowing for the differences, for the 'enormous Text' to reverberate.

A practical problem with attributing a visual practice to the professional life of Barthes is that he never sought to expose his drawings outside of a close circle. They remain within an amateur and private setting. Yet, here makes for a pertinent connection to Foucault's (1988) account of technologies of the self. Not long before his death in 1984, Foucault offered a faculty seminar, in which he suggests his shift away from questions of domination and power. At the heart of the seminar was a consideration of the differing historical emphasis – through Greek and Roman periods – upon the Delphic principle 'know yourself' and its corollary, 'care for yourself'. He quotes at length from a letter by Marcus Aurelius in AD 144–45, which opens with the very ordinary line 'I slept somewhat late owing to my slight cold . . .'. The letter goes on to present the description of everyday life. 'All the details of taking care of oneself are here,' Foucault explains, 'all the unimportant things he has done. Cicero tells only important things, but in Aurelius's letter these details are important because they are you – what you thought, what you felt'. The technologies of the self are revealed in terms of the body (and health) and also regulatory forms of writing (confessions, letters, reflections and diaries). In reference to writings of self-examination by Seneca, '[he] uses terms related not to juridical but to administrative practices . . . The rule is a means of doing something correctly, not judging what has happened in the past' (Foucault 1988: 33). Foucault goes on to suggest, 'it isn't a question of discovering truth in the subject but of remembering truth, recovering a truth which has been forgotten' (34). Foucault leads out to the idea that disclosure of the self requires the renunciation of the self. Yet, from the eighteenth century onwards techniques of disclosure 'have been reinserted in a different context by the so-called human sciences in order to use them without renunciation of the self but to constitute, positively, a new self. To use these techniques without renouncing oneself constitutes a decisive break' (49). Arguably, *Roland Barthes* – Barthes' fragmentary, autobiographical text – can be taken as a regulatory, administrative (rule-based) disclosure of the self. In the entry on his 'Schedule', he notes how in the afternoon, after an hour's nap, he is seemingly unable to get straight back to work – and by work he means writing. 'Then comes the moment when I drift', he says, 'no will to work; sometimes I paint a little, or I go for some aspirin at the druggist's, or I burn papers at the back of the garden, . . . by this time it is four, and I go back to work' (1977a: 82). Painting, then, is structured as 'drift' and as exercise, as in a break from work: To stretch one's legs. In terms, then, of defining a visual practice, there is the engagement of making language visible, or rather making visible alternative(s to) languages (the 'work' of elaborating

on the enormous Text). Practice, then, here equates to 'exercise' – a technology of the self – but, unlike Foucault's attention to writing, Barthes adopts drawing; in this case presumably because writing itself – in the common sense – is too much a part of what needs to be reflected upon and cared for. And in turn, this leads to a 'neutral' activity that is *somewhere between* working and not working.

Neutral Specificities

> I go out to buy some paints (Sennelier inks) . . . In putting them away, I knock one over: in sponging up, I make a new mess . . . And now, I am going to give you the official name of the spilled color, a name printed on the small bottle . . . it was the color called Neutral (obviously I had opened this bottle first to see what kind of color was this Neutral [. . .] Well, I was both punished and disappointed: punished because Neutral spatters and stains (it's a type of dull gray-black); disappointed because Neutral is a color like the others, and for sale (therefore, Neutral is not unmarketable): the unclassified is classified – all the more reason for us to go back to discourse, which, at least, cannot say what the Neutral is. (Barthes 2005: 48–9)

The term 'drift' is not one of the named figures in the *The Neutral* (Barthes 2005), but it would seem equally at home there. In common with many of the terms evoked in the lecture course, drift is a state or an intensity, and as such is not coded, or classified. In referring to 'weariness', for example, Barthes says it is 'not coded, is not received . . . [it] always functions in language as a mere metaphor, a sign without referent'. This is in contrast to depression and mourning, he suggests, which have been inscribed with 'social claims' (2005: 17). Barthes is very clear at the start of his lecture course, his definition of the Neutral 'remains structural' (7), and which again seemingly relates to an 'enormous Text' beyond mere vocabularies of signs, beyond the dominant discourse; beyond the 'arrogance' of language. Crucially, as Neil Badmington (2008) recounts, Barthes' recurring fascination with the accoutrements of writing sheds light on his account of Writing (with a capital 'W') to be both textual and physical (as alluded to above, for example, with reference to the mistyping of words). Again suggestive of the Amateur and drift, Barthes describes the writer as 'someone carried away, a breakneck, but not arrogant ⟶ a drive that generates a stubbornness in practice, not conviction, in idea: to believe in the importance of what one writes, not what one thinks ⟶

therefore: not loyalty to the idea, but persistence of a practice' (Barthes 2005: 162–3).

His choice in pursuing a practice (or the 'drift') of painting and drawing can be understood as a means towards a de-structured space, both representationally and as a site of practice. As noted in the introduction to this book, Barthes' complaint that in the cinema 'you are not permitted to close your eyes', can be understood to echo with the spaces in Victor Burgin's video works, where, he suggests, 'nothing happens', indeed where you are permitted to close your eyes without fear of missing out, or being misplaced. We might consider Barthes' drawings as his own place or space to inscribe 'significations' away from the usual structures of signification and power. However, the drawings do not attempt simply to efface structures and order. Barthes is too much the structuralist to believe it possible to draw outside of systems of signification; or that there might somehow be an 'outside' to the Text. He must always engage with structures if he is to outplay them. In almost all of the drawings, a very definite frame appears through the affordance of a generous margin on all four sides of the paper. This frame is not marked out beforehand. Instead, it would seem Barthes would decide upon, or imagine, the borderline of his designs as he worked; he would allow the frame to emerge upon the paper through his working and re-working of the various interconnected lines he draws. The delicate, or virtual, nature of the 'line' between where the drawing stops and the edges of the paper start is a visual play of Barthes' deep preoccupation with what he terms 'idiorrhythmy' – a productive form, or fine line between living with others, while maintaining one's own individual rhythms (Barthes 2013).

The concept of idiorrhythmy, developed in the lecture course *How to Live Together* (Barthes 2013), along with the interest in the Neutral (Barthes 2005) is typical of Barthes' utopic thinking (Knight 1997). He seeks a means to take up space for oneself without needing to encroach on another, or at least to determine a place of comfort, where you are near the other, but not too near (one might think of how a cat enters a room, to be with yet a-part from those already present!). And comfort here is hedonistic, where hedonism is understood not as the outright taking of pleasure, but rather the absence of suffering. As the novelist Milan Kundera puts it in *Slowness,* suffering 'is the fundamental notion of hedonism: one is happy to the degree that one can avoid suffering, and since pleasures often bring more unhappiness than happiness, Epicurus recommends only such pleasures as are prudent and modest' (Kundera 1996: 8). Similarly, Barthes' utopian thinking is concerned with modest and tactful undertakings. A repeated image in both *How to Live Together* and *The Neutral* is of a shoal of fish, as a

pattern of fluidity preserving 'tactful' spaces between (2005: 146; 2013: 37). As a form of living-together Barthes suggests this is 'the perfect image . . . one that would appear to effect the perfectly smooth symbiosis of what are nevertheless separate individual beings' (2013: 37). In visual terms, Barthes' paintings develop something similar, to produce what we might call a 'democracy of lines'. The relationship between figure and ground is frequently blurred, and crucially the mark-making relates to space between one and another rather than space in relation to another. In other words, when Barthes draws or paints, he marks out a set of de-hierarchical lines, where the coming together of lines is not to suggest of relational (power) properties, but a simpler being together. Also, the suggestion here of 'space between' is a nod to the Japanese aesthetic (such as in flower arranging) that Barthes found so attractive. Ikebana is from the Japanese *ikeru* (生ける, meaning to keep alive, arrange flowers, living) and *hana* (花, flower). The combined meaning of both 'giving life to flowers' and 'arranging flowers' is pertinent to how Barthes appears to 'arrange' his lines, allowing always for a space to breathe; to acknowledge the space between lines to be of an equal charge. As with Japanese flower arranging, it is not so much about how one element relates to the other, but rather how each takes its place within a broader frame, or we might say *khôra*. Again the image to conjure is of the individual fish maintaining its position within a swirling shoal. In thinking back to Benjamin's remarks on both painting and drawing, what emerges in Barthes' painting is not the sign, but the mark: an impossible structure emerges with 'marks' of emptiness, alongside a swirling frame of lines, as if 'simultaneously, contradictorily, incision and glissade' (Barthes 1982: 86).

Weariness: Without Measure

> On the one hand, what he says about the large objects of knowledge (cinema, language, society) is never memorable: the treatise (the article on something) is a kind of enormous falling off. Whatever pertinence there happens to be comes only in the margins, the interpolations, the parentheses, *aslant:* it is the subject's voice *off,* as we say, off-camera, off-microphone, offstage. (Barthes 1977a: 73)

Barthes' drawings vis-à-vis his own interest in the Neutral may allow some further speculation, taking Barthes' mark-making in a thematic direction, and extending beyond his own making of drawings. Let us suppose, for example, his works are a

form of 'weariness'; being one of the opening figures of the Neutral lectures. Quoting Blanchot, Barthes reminds us: 'It seems that, however weary you may be, you still accomplish your task, quite properly. One might say that not only does weariness not impede the work, but the work demands this being weary without measure' (cited in Barthes 2005: 20). Barthes is drawn to this 'without measure' that describes (or rather cannot describe) weariness. Consider now Gauguin's *Green Christ* (1889). The salient feature of this painting appears in the foreground: the mournful woman seated before a sculpture of Christ's crucifixion. However, as we look at this painting our eye is drawn to the small figure in the middle-distance. A lone, weary fisherman appears between the sand dunes, placed someway between the edge of the sea from where he has come (on the left of the painting) and the route which takes him beyond the picture frame (to the right). He is returning from a day's work (though perhaps being a fisherman the day still stretches forth for the rest of us). We can attempt to postulate that this figure is a delicate sighting/siting of the Neutral.

Barthes' identifies a root to weariness that is related to the body (labour, lassitude and fatigue). Labour, as Barthes suggests, is easily associated with a rural setting and with manual work, and it is a word we relate to class conditions. But weariness is harder to place. If anything, Barthes writes, 'it is hard to connect . . . with the worker's, the farmer's, the employee's manual or assimilated type of work'. He suggests the following experiment:

> . . . draw up a table of received (credible) excuses: you want to cancel a lecture, an intellectual task: what excuses will be beyond suspicion, beyond reply? Weariness? Surely not. Flu? Bad, banal. A surgical operation? Better, but watch out for the vengeance of fate! Cf. the way society codifies mourning in order to assimilate it: after a few weeks, society will reclaim its rights, will no longer accept mourning as a state of exception . . . (Barthes 2005: 17)

What interests Barthes about weariness is that it is not codified. Rather, it is unclassifiable:

> . . . without premises, without place, socially untenable → whence Blanchot's (weary!) cry: 'I don't ask that weariness be done away with. I ask to be led back to a region where it might be possible to be weary.' → Weariness = exhausting claim of the individual body that demands the right to social repose (that sociality in

me rest a moment . . .). In fact, weariness = an intensity: society doesn't recognize intensities. (Barthes 2005: 17–18)

Returning, then, to the fisherman in Gauguin's *Green Christ,* we can now see this (neutral) weariness in just a mere fleeting scene. Indeed, is it through a certain visual presentation that we can allow for intensities to be seen? There is the juxtaposition of what is heavy and angular in the foreground and the delicate S-bend of the fisherman. His is an existence of labour, returning from work. He is a 'tire that flattens' – to borrow a phrase from Barthes, who in turn is echoing a line from Gide (Barthes 2005: 16). While in the foreground is the weight of a spiritual (intellectual?) realm. The latter is heavily codified. It inscribes one's right to think. The former, however, is ambivalent. The fisherman walks away (freely?) from his responsibility (if only until tomorrow). Is he content in his weariness? He seems to lead up to 'a region where it might be possible to be weary'. . . to be neutral, to care for the Self. Thus, we can consider how this figure (here, admittedly, deftly drawn (in) by a Master painter) bears close relation to the many lines by Barthes. This is certainly not to equate Barthes to Gauguin, but rather to mine a seam of mark-making and line drawing: simple, gestural, painterly figures that otherwise get swept up, becoming merely unattributed or near-illegible 'phrases' or 'characters'. They exist only as low intensity, hard to detect. Barthes' undulating and coagulating lines – which in themselves bear the 'carnal, lubrified flexibility of the hand' (Barthes 1982: 86) – are a mass of fisherman and fishes, all flattened; yet eminently alive in their weariness. They are the unrecognised intensities of a writer who takes pleasure at a graphic level.

References

Badmington, Neil (2008) 'The "Inkredible" Roland Barthes', *Paragraph*, Vol. 31, No. 1, pp. 84–94.

Barthes, Roland (1975) *The Pleasure of the Text,* trans. by Richard Miller. New York: Hill and Wang.

Barthes, Roland (1977a) *Roland Barthes,* trans. by Richard Howard. Berkeley: University of California Press.

Barthes, Roland (1977b) *Image Music Text*, trans. by Stephen Heath. London: Fontana.

Barthes, Roland (1978) 'Le degree zero du coloriage', *Les Nouvelles Littéraires*, 30 March 1978, in *Œuvres completes, Tome V, 1977–1980.* Paris: Éditions du Seuil, p. 453.

Barthes, Roland (1981) *Carte Segni.* Milano: Electa.

Barthes, Roland (1982) *Empire of Signs*, trans. by Richard Howard. London: Jonathan Cape.

Barthes, Roland (1985a) *The Grain of the Voice: Interviews 1962–1980*, trans. by Linda Coverdale. New York: Hill and Wang.

Barthes, Roland (1985b) *The Responsibility of Forms: Critical Essays on Music, Art, and Representation*, trans. by Richard Howard. New York: Hill and Wang.

Barthes, Roland (1989) *The Rustle of Language*, trans. by Richard Howard. Berkeley: University of California Press.

Barthes, Roland (2005) *The Neutral: Lecture Course at the Collège de France (1977–1978)*, trans. by Rosalind E. Krauss and Denis Hollier. New York: Columbia University Press.

Barthes, Roland (2009) *Mythologies* (originally published 1957), rev. edn trans. by Annette Lavers. London: Vintage.

Barthes, Roland (2013) *How to Live Together: Novelistic Simulations of Some Everyday Spaces*, trans. by Kate Briggs. New York: Columbia University Press.

Benjamin, Walter (2004) 'Painting, or Signs and Marks' in *Selected Writings, Volume 1, 1913–1926*, ed. by Marcus Bullock and Michael W. Jennings. Cambridge, MA: Harvard University Press, pp. 83–6.

Clerc, Thomas (2011) 'Dessin de Roland', *in Dessins d'écrivains: de l'archive à l'oeuvre*, ed. by Claire Bustarret, Yves Chevrefils Desbiolles and Claire Paulhan. Paris: Manuscrit.

Foucault, Michel (1988) *Technologies of the Self: a Seminar with Michel Foucault*, ed. by Luther H. Martin, Huck Gutman and Patrick H. Hutton. London: Tavistock.

Knight, Diana (1997) B*arthes and Utopia: Space, Travel, Writing*. Oxford: Clarendon.

Kundera, Milan (1996) *Slowness*, trans. by Linda Asher. London: Faber and Faber.

Milner, Marion (1986) *On Not Being Able to Paint*, 2nd edn. London: Heineman.

Michaux, Henri (2006) *Stroke by Stroke*, trans. by Richard Sieburth. New York: Archipelago Books.

Ungar, Steven (1983) *Roland Barthes: The Professor of Desire*. Lincoln: University of Nebraska Press.

Reading Barthes

Victor Burgin and Sunil Manghani

> He sometimes used to regret having let himself be intimidated by languages. Then someone said to him: But without them, you wouldn't have been able to write! Arrogance circulates, like a strong wine among the guests of the text. The intertext does not comprehend only certain delicately chosen, secretly loved texts, texts that are free, discreet, generous, but also common, triumphant texts. You yourself can be the arrogant text of another text. (Barthes 1977a: 73)

The following correspondence between Victor Burgin and Sunil Manghani was compiled in the lead-up to the exhibition, *Barthes / Burgin,* at the John Hansard Gallery (2016). It is part of a longer dialogue that is currently in preparation, which takes its framing from Victor Burgin's *Components of a Practice* (Burgin 2008). In this book, Burgin offers critical reflections on his practice as it emerged in the 1960s through to the present. The book is divided into four main elements: beginnings, evolution, ideology and specificity. While these headings are not stated explicitly in the following text, they can be understood to nonetheless guide the unfolding correspondence that examines the work of Roland Barthes, and particularly Burgin's 'reading' of Barthes.

*

Sunil Manghani: Roland Barthes is mentioned only a few times in *Components of a Practice,* yet I think it is fair to say his influence echoes across much, if not all, of your work. You write: 'Anyone who practices an occupation over a period of years will have a sense that it involves a number of constants. Some of these "components" of a practice are common to all, others vary between individuals and over time' (Burgin 2008: 10). We might regard Barthes as one of these 'components' – certainly a common influence for many artists working from the 1970s onwards, and, as we'll consider here, of particular and changing significance for your own work. In fact, just in the first couple of pages of your introduction to *Components of a Practice,* Barthes' resonance can be heard, both as a constant and a shifting presence.

You note, for example, how your work has been 'fundamentally concerned with relations between words and images, with hybrid "scripto-visual" forms in which neither picture nor text predominate' (Burgin 2008: 11). This same fundamental relationship lies at the heart of Barthes' oeuvre. And indeed a similar rubric is presented in his *Empire of Signs:* 'The text does not "gloss" the images, which do not "illustrate" the text. For me, each has been no more than the onset of a kind of visual uncertainty [. . .] Text and image, interlacing, seek to ensure the circulation and exchange of these signifiers: body, face, writing . . .' (Barthes 1982: np). This, then, is a constant. However, there is equally an interesting shift or oscillation noted in your introduction to *Components of a Practice.* In referencing your early photographic work, which itself might be framed with regards to the impact of the semiotic research and engagement with sociopolitical 'texts' found in Barthes' early writings (along with other semioticians of the time), you make reference to the term 'zero degree' (suggesting a 'return to a semi-autonomous "zero degree" of photography in the panorama of my recent videos . . .' (Burgin 2008: 11)). This phrase 'zero degree' is, of course, strongly associated with Barthes' first book, *Writing Degree Zero,* from 1953, and relates to a movement within post-war literature. That book makes an important argument for 'writing' as distinct from language and style (or body) – which perhaps might also suggest of a certain constant in your work: a search for a form of 'writing'. Yet, equally, in the very next line, you refer to the idea of the 'grain' of the voice in your video work, which, of course, is again a reference associated with (a later) Barthes. He writes: 'The "grain" is the body in the singing voice, in the writing hand, in the performing limb' (1985b: 276). This appears to take us back to questions of style, but through the lens of *pleasure,* or an attempt to enquire at a glance, over one's shoulder; within the realms of a third, or obtuse meaning, and the *punctum.* I'd like to move through these 'incidents' with Barthes, but to start with we should pose a more rudimentary question – one that I think Barthes himself would surely approve of, and equally reveal to be a far more complex question than we bargain for: When did you first come to read Barthes, and/or when did you first come to acknowledge you were engaged in a reading of Barthes?

Victor Burgin: It would have been somewhere around 1971, I no longer remember exactly when. I was in my first job, teaching at Nottingham School of Art, and had become friendly with someone with a background in anthropology. I believe we had bonded over Georges Charbonnier's *Conversations with Claude Lévi-Strauss,* which I had read in English translation in this small Jonathan Cape edition. I would guess it was this that led my colleague to

recommend that I read *Elements of Semiology,* which had also been translated for Cape. It was a 'Saul on the road to Damascus' moment in my intellectual history. After that first reading – of course it's a book I continued to reread – I went looking for other books by Barthes and found only *Writing Degree Zero,* in the same Cape series. There were no other English translations of Barthes available at that time. So I went to Paris and came back with a bag full of assorted texts, not only by Barthes but also by the writers he draws on in *Elements*. I bought myself a large French–English dictionary and sat down to work my way through them. An irony lost on me at the time was that *S/Z* had just appeared in France, signalling Barthes' post-structuralist turn. Barthes later spoke of the way his investment in intellectual projects was a desiring one, they would endure for whatever periods of time they endured, like amorous investments, and then be overtaken by other passions. The affair with linguistic theory that gave birth to *Elements,* however, was arguably the longest and most intense.

SM: In *Components of a Practice,* you note your encounter with A.J. Ayer's *Language, Truth, and Logic,* which you read at art school in the 1950s. Even now, in general conversation, I sense this book remains an important touchstone. As you explain:

> In this book Ayer argues that a sentence can be meaningful only if it is 'analytic' (tautological, like mathematics), or empirically verifiable. If a sentence is neither, it is literally nonsensical. Ayer applies this 'verification principle' to ethical, theological and aesthetic propositions. All fail the test and are condemned as meaningless. This chance introduction to Ayer's book came at the right moment for me. I was having difficulty making much sense of what painting tutors and art critics were saying. It came as a relief to learn they were talking nonsense. This was the beginning of my search for an appropriate critical language for thinking through my art practice. (Burgin 2008: 15)

Barthes represents a very different 'proposition'! He writes, for example, how in a novel such as *Robinson Crusoe* 'there is a historical knowledge, a geographical, a social (colonial), a technological, a botanical, an anthropological knowledge (Robinson proceeds from Nature to culture)' (Barthes 2000: 463); and that if we had to make a choice between all disciplines, we should save literature, since it contains everything else. However, it is not simply literature's encyclopaedic predilections that are important, it is what it does to/with knowledge:

[it] displaces the various kinds of knowledge, does not fix or fetishize any of them; it gives them an indirect place, and this indirection is precious. On the one hand, it allows for the designation of possible areas of knowledge – unsuspected, unfulfilled. Literature works in the interstices of science. It is always behind or ahead of science . . . The knowledge it marshals is, on the other hand, never complete or final. Literature does not say that it knows something, but that it knows *of* something . . . (Barthes 2000: 463)

As you note, you came to read Barthes later than when first reading A.J. Ayer. Along with his criticisms of Derrida, Ayer would no doubt consider Barthes a rhetorician. However, what was your reading of Barthes and what was going on at this time for you with regards your practice?

VB: My encounter with Ayer, and with logical positivism in general, was almost as important to me as my encounter with Barthes some fifteen years later. One can hardly think of two more different thinkers, but they nevertheless performed complementary functions for me. Ayer allowed me to clear the ground of the kind of impressionistic and opinionated writing that was rife in so-called 'art criticism'. Barthes allowed me to construct an alternative critical apparatus once that ground was cleared. I was surprised that you referred to Barthes as a 'common influence' for artists from the 1970s onwards. Apart from myself I don't know of any artist at that time who was even aware of Barthes, much less reading him. The conceptualists I tended to be associated with then, mainly the Art-Language group, trod the British 'natural language philosophy' line of hostility to what they called the 'French disease'. The people who *were* reading Barthes were the film theorists around *Screen* magazine. I later became friendly with some of them, mainly with Peter Wollen and Laura Mulvey, but in the early 1970s I was pretty much intellectually isolated.

SM: Yes, perhaps the artists I'm thinking about do come a little later. And, certainly, I recognise the point that it is with regards to film that Barthes is perhaps being more widely read. Those connected with the London Film-Maker's Cooperative, for example, as I understand it, were reading him. Of course, in trying to contextualise your reading of Barthes I'm likely in danger of implying a 'grand' reading of Barthes. There is a lovely line in Barthes' essay 'On Reading', in which he says: 'The library is a space one visits, but not that one inhabits' (Barthes 1989: 37). I'm interested in how Barthes brings us to 'visit' his writings, rather than inhabit them or build upon

them. In knowing your work, and indeed your particular interest in remembered fragments, I imagine your reading of Barthes might be broken into fragments and phases. In interview, Barthes is referred to as a critic who 'loves to read'. He responds in typical fashion:

> I wouldn't want to deprive you of an illusion, all the more so in that I do love to read. But I'm not a great reader, I'm a casual reader, casual in the sense that I very quickly take the measure of my own pleasure. If a book bores me, I have the courage, or cowardice, to drop it. I'm freeing myself more and more from any superego in regards to books. So, if I read a book, it's because I want to.
>
> My reading schedule is not at all a regular and placid ingestion of books. Either a book bores more and I put it aside, or it excites me and I constantly want to stop reading it so that I can think about what I've just read – which is also reflected in the way I read for my work: I'm unable, unwilling, to sum up a book, to efface myself behind a capsule description of it on an index card, but on the contrary, I'm quite ready to pick out certain sentences, certain characteristics of the book, to ingest them as discontinuous fragments. This is obviously not good philological attitude, since it comes down to deforming the book for my own purposes. (Barthes 1985a: 220–1)

The 'amateur' is a recurring figure for Barthes. Here he refers to himself as a 'casual' reader. As noted elsewhere in this book, the amateur is an important figure for *The Pleasure of the Text,* and there is a specific entry in *Roland Barthes:*

> The Amateur (someone who engages in painting, music, sport, science, without the spirit of mastery or competition), the Amateur renews his pleasure (*amator:* one who loves and loves again); he is anything but a hero (of creation, of performance); he establishes himself *graciously* (for nothing) in the signifier: in the immediately definitive substance of music, of painting; his praxis, usually, involves no *rubato* (that theft of the object for the sake of the attribute); he is – he will be perhaps – the counter-bourgeois artist. (Barthes 1977a: 52)

I think you position yourself similarly when you refer to having difficulty 'making much sense of what painting tutors and art critics were saying'. The relief in realising that perhaps they are indeed talking nonsense is not simply a resolution of a problem,

but a point of departure. The amateur is important for Barthes as a means both to destabilise hierarchies and to return us to questions of *pleasure* – to respond as a form of *writing*. I wonder if this was something you were drawn to in reading his work? His remark on wanting to stop reading something when it excites is perhaps a good description of what we most take away from Barthes and why he has remained of interest for many creative practices. In this sense, it is not necessary that we make a full reading of Barthes. I'm inclined to think of Derrida's confession of having *not* read Barthes. The plural in Derrida's (2001: 31–67) title, 'The Deaths of Roland Barthes' is important. He must leave his thoughts fragmentary, to value the incomplete: 'These little stones, thoughtfully placed, only one each time, on the edge of a name as the promise of return' (2001: 35).

> Roland Barthes is the name of a friend whom, in the end, beyond a certain familiarity, I knew very little, and of whom, it goes without saying, I have not read everything. I mean reread, understood and so on. And my first response was most often certainly one of approval, solidarity, and gratitude. Yet not always, it seems, and as insignificant as it may be, I must say this so as not to give in too much to the genre. He was, I mean, he remains, one of those of whom I have constantly wondered, for almost twenty years now, in a more or less articulated way: What does he think of this? In the present, the past, the future, the conditional, and so on? Especially, why not say it, since this should surprise no one, at the moment of writing. I even told him this once in a letter long ago. (Derrida 2001: 56)

VB: Just as there is great intellectual rigour in Barthes there is also a great permissiveness. You might say the one is nourished by the other because the permissiveness often takes the form of an attention to detail. I forget where it is that he talks about the different ways in which one can read, but he includes such things as skipping through a book taking in passages at random. We all do that, but I remember that at the time I first read that it was something I felt guilty about. Barthes also speaks of knowing books 'by osmosis' – he hasn't actually read them but has heard enough talk about them to be familiar with them. Of course you need to contextualise remarks like that, French print and broadcast media provide a quantity and level of intellectual discussion unimaginable in Britain and the United States. For all Barthes speaks of his 'undecided' relation to psychoanalysis, I always find his relation to the world scrupulously analytic if only in the sense that nothing in his experience is considered, a priori, insignificant, in the sense of unworthy of attention. Jonathan Culler

tells a great story about the time he was a graduate student at Oxford. Barthes had been invited to the university and Culler was given the task of showing him around the colleges and gardens. He says that Barthes quickly and obviously became bored, so he asked him if there was anything in particular he would like to see. Barthes said he'd heard that the British had electrical plugs very different from those in France, and could they go somewhere where he could see them. So they spend a happy forty-five minutes at Woolworths, looking at 'insignificant' objects of everyday British life.

SM: We've come together to discuss the influence of Barthes in light of the exhibition at the John Hansard Gallery, *Barthes / Burgin,* for which we have brought together some of your recent projection works and a selection of drawings by Roland Barthes. These might not seem natural bedfellows. Two very different mediums. In your case the works are resolutely artworks, involving painstaking 3D modelling and lots of attention to detail. While Barthes' works on paper are more akin to automatic writing; mere exercises in mark-making. Crucially, Barthes is not an artist, and would never have suggested as much. If we think of artists such as Cy Twombly (whom Barthes admired), Mark Tobey and Simon Hanteï, there are resonances – each (at different points in their careers) work around the boundary of writing and drawing. Yet there is a very different sense of scale, composition and material process that quickly marks them out as practitioners. By contrast, Barthes hovers about the boundary between writing and drawing, but only as a dalliance, as an escape from the fact that he is a writer (underneath the reproduction of one of his drawings in *Roland Barthes,* for example, he captions it simply 'Squandering' (Barthes 1977a: 113)). His motor-reflex is to scribble not mark. Nonetheless, there is a latent artist in Barthes (in his book, *Roland Barthes: The Professor of Desire,* Stephen Ungar has suggested a repressed artist, though I'd disagree). This becomes apparent in his late career, and is captured explicitly in his inaugural lecture at the Collège de France, in which he claims the semiologist needs to be an artist playing with signs 'as with a conscious decoy, whose fascination he savours and wants to make others savour and understand'. The sign for this artist 'is always immediate, subject to the kind of evidence that leaps to the eyes, like a trigger of the imagination', which is why semiology in this case 'is not a hermeneutics: it paints more than it digs' (Barthes 2000: 475). I have always liked this line. A book such as *Empire of Signs* is a good example of what it might look like for the semiologist to paint rather than dig. We know also, from *Roland Barthes,* how Barthes was concerned with his place of work, in situating a space for freedom

and creativity: 'My body is free of its image-repertoire only when it establishes its work space. This space is the same everywhere, patiently adapted to the pleasure of painting, writing, sorting' (Barthes 1977a: 38). Again, without wanting to categorise Barthes as an artist as such (at least not in the everyday sense of the term), it seems pertinent today, within the context of a 'return' to Barthes (see 'Barthes, Burgin, *Barre oblique*'), to reflect upon his influence within the visual arts and creative practice. An underlying tenet of the exhibition, in a sense, has been to consider yourself and Barthes as being *both* artists and writers. In your own case, of course, you have long been admired as both theorist and practitioner. However, in focusing on Barthes' *practice* of painting and drawing, there is an occasion to revisit the terms theory/practice, writing/making and criticality/visuality etc. In your essay on the emergence of the practice-based PhD (Burgin 2006), you refer to several different types of researcher. I wonder how we might imagine Barthes as one of these types, and/or what influence he might still have in thinking through these different approaches. To clarify, you refer to the PhD candidate who is 'both an accomplished visual artist and who not only wants to write, but is capable of writing, a long dissertation' (2006: 103). Another type is 'one who received a thorough introduction to a specialist academic literature as an undergraduate, but has little experience of practical work in visual arts' (103–4); and finally there is the third, and arguably the most common type: 'one who makes works of art and who also reads enthusiastically. This student is interested in ideas, and turns concepts encountered in reading into practical projects. The research of this type of candidate typically has a mainly practical outcome, with academic work playing a subordinate and "instrumental" role' (104). You give an example of a student who reads both Bachelard and your own book on 'space', before making an installation of stuffed toys turned inside out. As you note, '[t]here is nothing in either Bachelard or in [your] own work to recommend this treatment of stuffed toys, but if this person had not read the theory he might not have thought of doing this' (104). You go on to point out, the question raised is not whether the student is engaged in 'research', but more simply how they can be assessed.

... visual arts departments confidently assessed such students before the coming of the PhD. Throughout the history of art the finished 'work of art' has represented the culmination of a process of research; a large part of the routine *work* of artists is a work of research. Although the shift from a language of 'creativity' to a language of 'research' may confuse that part of commonsense inherited from nineteenth-

century Romanticism it is otherwise easily justified historically. The question of whether visual art production constitutes research is not a significant issue. The substantive issue for visual arts departments now is the widespread inability or disinclination to clearly distinguish between an art work and a written thesis, a tendency to obfuscate or ignore the differing specificities of two distinct forms of practice. (Burgin 2006: 104–5)

It is worth remembering that back in 1979, it was Barthes who accepted a PhD thesis made up solely of photographs, by Lucien Clergue. I'm not sure if recognition in the scholarly value of creative works in this way is possible now.

VB: This may be the moment to remind whoever may be reading our exchange that although the exhibition you conceived of has opened in 2016 it was originally planned to open the previous year, to mark the centenary of Barthes' birth. Your juxtaposition of my own work with that of Barthes is an act of collage I have accepted as your creation of 'an object to think with' – otherwise, as the English expression goes, 'there's no comparison'. But to enter into the game again, we might say that there are two mainly unrelated situations in play. You earlier cited Barthes from *Empire of Signs*, where he speaks of the 'interlacing' of text and image, in which the text does not 'gloss' the image, and in which the image does not 'illustrate' the text. In a memoir about Barthes, Éric Marty (2006) describes Barthes at work writing, with different coloured pencils and inks, to mark additions, corrections and so on. The closest I've come to writing as painting was during my early years as an art student, when one of my enthusiasms was for the work of Stuart Davis. I emulated Davis by incorporating words into my otherwise abstract works, making the forms and colours of the letters part of the overall design. My mature work has of course been on the side of the 'interlacing' that Barthes describes, with the rider that something I was very much aware of when doing photo/text work was that the photographic grain on the surface of the paper formed both the image and the letters, and that this is also true of the pixel structure of my later computer-based work. I don't know what the circumstances of Lucien Clergue's doctoral degree were, nor do I have any idea what relationship he had with Barthes. The issue of doctoral degrees for artists started to be discussed in France only two or three years ago, some time after similar discussions began in the United States and well after such degrees became an established fact in the UK. To my knowledge there are still no doctoral degrees for artists in France, so I would guess that Lucien Clergue's degree was an exception. Clergue seems to have been one of those individuals to whom nothing is denied. He 'knew everyone', as the expression

goes, and wound up being inducted into the French Academy wearing a costume and épée designed by Christian Lacroix – a spectacular crowning of an artistic reputation based on pictures of long-suffering gypsies and naked girls. My own concern, when I first encountered PhDs for artists on my return from teaching in a graduate cultural studies department in the United States, was that the newly 'doctored' artists might go on to supervise written theses. I was worried about the quality of teaching that would result. Apart from that concern, I'm on the side of the Wizard of Oz when he argues for the superfluity of degrees and decorations of all kinds. Barthes himself, of course, because of his long isolation due to his tuberculosis, had none of the academic qualifications that his intellectual peers would routinely have had.

SM: I'd like to turn to the period of the late 1970s and early 1980s, a time when there appears to be an important shift taking place in your work. In 1973 you leave a fine art department to take up a post in a department of film and photography (in the School of Communications at the then Polytechnic of Central London). This must have been a big decision at the time. What attracted you was the engagement there in social documentary, and you published your book *Thinking Photography* in 1982, which remains a key document from this period. However, you also note how your attention shifts from issues of gender to sexuality. You write:

> It seemed that the complex of unconscious forces at play in the working out of sexual difference might be the matrix within which all subsequent forms of pathological love and hatred, idealization and abjection, were formed – including those driving such phenomena as homophobia and racism. [. . .] After years of subordinating the image to the kind of 'semioclasm' recommended the Roland Barthes of *Mythologies,* I began to allow the image its power of fascination. (Burgin 2008: 52)

I appreciate there are many other reference points and influences at this time, but I am interested how your reading of Barthes might have altered. Both, the texts you were drawn to and how you were interpreting them. There appear to be some parallels in your thinking. For example, you draw here on psychoanalytical terms and ideas, and similarly Lacanian terms begin to show up in Barthes' later writings. It is also interesting you refer to 'semioclasm'. This appears in Barthes' reflection on *Mythologies,* written in 1971, in the article for *Esprit,* 'Change the Object Itself' ['Changer l'objet lui-même'] (Barthes 1977b: 165–9). Barthes actually uses the term to articulate the need of a new approach, to overcome the 'mythology doxa' that has been created (not

least in part by his own contribution to semiotics) – which I'd suggest tallies with your interest 'to allow the image its power of fascination'. Barthes writes:

> In an initial moment, the aim was the destruction of the (ideological) signified; in a second, it is that of the destruction of the sign: 'mythoclasm' is succeeded by a 'semioclasm' which is much more far-reaching and pitched at a different level. [. . .] Thus, rather than myths, it is sociolects which must today be distinguished and described; which means that mythologies would be succeeded by an idiolectology – more formal and thereby, I believe, more penetrating – whose operational concepts would no longer be sign, signifier, signified and connotation but citation, reference, stereotype. [. . .] This is no more than a programme, perhaps only an 'inclination'. I believe, however, that even if the new semiology . . . had not applied itself further to the myths of our time since the last of the texts in *Mythologies* where I sketched out an initial semiotic approach to social language, it is at least conscious of its task: no longer simply to *upend* (or *right*) the mythical message, to stand it back on its feet, with denotation at the bottom and connotation at the top, nature on the surface and class interest deep down, but rather to change the object itself, to produce a new object, point of departure for a new science, to move – with all due allowance for difference in importance (obviously) and according to Althusser's scheme – from Feuerbach to Marx, from the young Marx to the mature Marx. (Barthes 1977b: 167–9)

I'm interested if this material is already circulating within your thinking (published in French in 1971, translated around 1977), or if your engagement is through a wider discourse at the time. I've also found this article by Barthes – as a historical document – extremely illuminating and provocative. However, it is elliptical. What does it really mean to 'change the object', or more to the point to change the 'sign'? The line 'it is at least conscious of its task' is most suggestive. What is he attributing consciousness to? Is it the semiologist? The system of signs itself? The field of practitioners within semiology? Or even the readers of signs themselves? It strikes me that as an *artist,* and with the shift you are making to the image as *fascination,* it is a particularly fertile time for *making* a difference, and to be able to move into a new intellectual space that the theorist has marked out, but is not seemingly able to complete.

VB: Barthes rarely defines his terms, he rather leaves it to the reader to 'catch his drift'.

My own understanding of what it means to change the object is in good part Foucauldian in inspiration: objects do not so much sit in the world waiting to be described, they are more fundamentally constituted *within* the descriptions. A table is a different thing to a structural engineer from what it is to an antique dealer. All objects in this sense are discursive objects, you 'change the object' if you change the discourse. My intention when I put together *Thinking Photography,* which came out of my teaching at the Polytechnic of Central London, was to change the object 'photography' as it was then constituted within the hegemonic discourses of the time – for example, in such British photo magazines as *Amateur Photographer, Zoom and Creative Camera,* the last of these of course in turn grounded in the institutional-discursive power of John Szarkowski, the then director of the New York MOMA, who could create 'great photographers' by naming them. The taking into account of the *fascination* that photographs may exert emerged as an internal necessity within my teaching. A semiotics that takes its analytical categories from structural linguistics is enormously effective in parsing the public meanings of images, but is hard pressed to account for the fact that when we look at one image we may find ourselves thinking of another, and has nothing at all to say about the affective power of photography. It was here that I found psychoanalysis had the most to contribute to filling in these lacunae in the maps of photographic meaning.

SM: In 1986 your book *The End of Art Theory* is published. As noted in the subtitle, this book faces head on the emerging debates of postmodernism. The book includes two essays directly concerned with Barthes' writing. The first of these, 'Re-Reading *Camera Lucida*', closes with a lovely anecdote:

> Barthes was once asked at the end of a lecture, by someone obviously irritated by what they took to be Barthes's willful 'difficulty', if the Freudian 'superego' wasn't really just what we all know as 'conscience'. Barthes replied: 'Yes, if you leave out all the rest'. It was rather like being asked if 'lightning' isn't the same thing as 'Zeus's thunderbolt' – yes it is, if you're happy to ignore the difference between the 'world-view' of modern meteorology and that of classical mythology."
> (Burgin 1986: 91)

Camera Lucida is of course the last book Barthes completed in his lifetime, giving added poignancy (indeed there is a double poignancy in that the book is itself about mourning). Alongside *Mythologies,* it is perhaps *the* most cited of his books (Batchen 2009; Elkins 2011). It has become a canonical text, and as if providing a new theory

of a private semiotics. My reading of this book, however, is of a *performance* of theory (as well as a genuinely, heartfelt search for what is forever lost). I don't think the introduction of its two critical terms, *studium* and *punctum*, were ever meant as generalisable terms. I feel it was always intended to be an enigmatic book. As such, what is the status of the book? Your essay, 'Re-Reading *Camera Lucida*' (Burgin 1986: 71–92), was one of the first critical introductions to the book, but you don't necessarily reveal what you personally take from the book – and perhaps how it might have affected your practice at the time. No doubt, given its *writerly* status, your view upon it will have altered many times since . . .

VB: My first reaction to *Camera Lucida* was one of dismay. If I stay with the analogy of Barthes' desiring relationships to his intellectual objects then I might say that he treated his discarded lovers badly, or rather disparaged the lover he himself had once been. For many years *Elements of Semiology* was the core text of the introductory course I gave to photography students at the then Polytechnic of Central London. Their reactions varied widely. One woman left the course saying she didn't see why she had to fight World War III in order to take a photograph. On another occasion I was in a London pub when an ex-student lumbered over to me in a state of inebriation and told me he was really grateful to me for having taken him through *Elements*. He said, 'I know now that if I can read that, I can read anything!' If the acceptance of semiotics could not be guaranteed even inside PCL – where students were warned at interview what kind of intellectual work they would be expected to do – then it was simply anathema beyond the walls. It was obvious to me that *Camera Lucida* would be read as a deathbed act of repentance in which Barthes renounced the wayward errors of his youth. *Elements* was the culmination of work that had begun with his early writings on the theatre and the essays collected in the volume *Mythologies*, work in which he stated unequivocally that 'the enemy is the bourgeoisie'. I knew that *Camera Lucida* would be received as a gift by that same bourgeoisie. But it got worse, I thought *Camera Lucida* would be read as a rejection of theory, it never occurred to me it would be treated as theory. As theory, most of what is in *Camera Lucida* had already been laid out in more detail by Sartre, which Barthes acknowledges when he dedicates the book to Sartre's 1940 *L'Imaginaire*. The distinction between public and private meanings of an image was something we talked about in my *Elements* classes, but in much less elegant terms than in the 'studium'/'punctum' distinction – which can therefore be a useful rhetorical aid in teaching, but only if it is *explained*, which is one of the things I tried to do in my article about the book. I saw *Camera Lucida* as an elegant book of mourning, Barthes' meditation on the

one image he does not show – the 'winter garden' photograph of his mother. I didn't really take anything from it.

SM: I want to turn to the theme of utopia in Barthes work. His writings often evoke an 'as if . . .' – as if things might be different, or as if something might be the case. 'I have a utopian imagination,' Barthes writes, 'and very often when I write, even if I'm not referring to a utopia, if, for example, I'm analysing particular notions in a critical way, I always do this through the inner image of a utopia: a social utopia or an affective utopia' (cited in Knight 1997: 1). Michael Wood (2015) takes this further, making the point that Barthes' relationship is necessarily about escape. '[E]ven the most brilliant remark', he notes, 'will be a prison if it arises only from the language of others, that there is no use of language that does not stand in need of subversion' (Wood 2015: 11). Thus, '[w]hen Barthes thinks of literature he thinks precisely of an escape from the language of others' (10) – as if it might be somehow different. The close of an essay that I think has been quite important to you, 'Leaving the Movie Theatre' (Barthes 1989: 345–9), ends with a tempting possibility: '. . . it is, one might say, an amorous distance: would there be, in the cinema itself . . . a possible bliss of *discretion?*' (349). The trope of 'as if' is also explicit in his lecture on Proust, 'Longtemps, je me suis couché de bonne heure . . .' (Barthes 1989: 277–90), in which he posits the possibility of writing a novel (a virtual project that is taken up in earnest in his final lecture course, *Preparation for the Novel*):

It is important for me to act *as if* I were to write this utopian novel. And here I regain, to conclude, a method. I put myself in the position of the subject who *makes* something, and no longer of the subject who speaks *about* something: I am not studying a product, I assume a production; I abolish the discourse on discourse; the world no longer comes to me as an object, but as a writing, i.e., a practice: I proceed to another type of knowledge (that of the Amateur), and it is in this that I am methodical. 'As if': is not this formula the very expression of scientific procedure, as we see it in mathematics? I venture a hypothesis and I explore, I discover the wealth of what follows from it; I postulate a novel to be written, whereby I can expect to learn more about the novel than by merely considering it as object already written by others. (Barthes: 1989: 289-290)

In viewing your work, particularly your projection pieces such as *A Place to Read* (2010)

and *Parzival* (2013), I sense something akin to Barthes' 'as if . . .'. And in fact, your essay 'Geometry and Abjection', from 1987, closes with a rather Barthesian line: 'It cannot, of course, be what it was at the time of Courbet, or even of Brecht. Attention to psychical reality calls for a *psychical realism* – impossible, but nevertheless . . .' (Burgin 2009: 197) – the three dots of the ellipsis being the very end of the article. *As if . . .* Is it fair to characterise your work in this way? We could perhaps take it further with reference to your use of the panoramic viewpoint. In *Components of a Practice* you suggest that in retrospective you realise much of your work has deployed a panoramic framing of one kind or another. More significantly, you suggest panoramic photography has been a means by which you seek a form of 'photography degree zero'.

> Composition is the corollary of framing, but the panoramic scanning of a still image produces a frame that is 'acompositional' (much as one speaks of the 'atonal' in music); the contents of the moving frame are in a perpetual state of *de*-composition as the result of the constant, mathematically uniform, passing of all that is visible. As there is no parallax, there is no differential movement between foreground, middle-distance and background – as there would be if the pan had been conventionally filmed by a camera operator. This is an incorporeal form of vision, the view of a disembodied eye turning upon a mathematical point of zero dimensions. Neither does the way in which the visible world enters and leaves the frame owe much to the optical schemas at work in cinema, as this movement is a product of mathematical calculations rather of the characteristics of glass lenses. This is a *theoretical* vision. (Burgin 2008: 92)

Barthes includes a short entry on 'panorama' in *The Neutral* (2005). His account is far less technical, but nonetheless resonates with your interest in the 'degree zero' – indeed Barthes considers the panorama as being 'on the side of the Neutral'. He offers a useful contrast with the panopticon:

> Panopticon: endoscopic device: presupposes the existence of an interior to be discovered, of an envelope (the walls) to be pierced: vital metaphor = the shell that needs to be cracked in order to access the core ≠ panorama: opens onto a world without interior: says that the world is nothing but surfaces, volumes, planes, and not depth: nothing but an extension, an epiphany (*épiphaneia* = surface) (Barthes 2005: 163)

Picking up on the idea of 'theoretical vision', this again suggests to me an 'as if . . .', a hypothesis or even an image (or seeing) of a utopia. While technically it is very different, your acomposition and an inhuman vision brings to my mind the early essay by Roland Barthes, from 1953, on seventeenth-century Dutch painting. Barthes begins with reference to Saenredam, who he describes as 'a painter of the absurd [. . .] To paint so lovingly these meaningless surfaces, and to paint nothing else – that is already a "modern" aesthetic of silence' (Barthes 2000: 62). By the end of the essay we learn that the aesthetic is of the gaze itself. Barthes ends with the enigmatic line: 'Depth is born only at the moment that spectacle itself slowly turns its shadow toward man and begins to look at him' (73). Perhaps, with respect to your interest in the panorama, you might hold some affinity with a spectacle's own shadow turning itself out to look at the viewer? Of course, the circular nature of the panorama is not to be underestimated. As with the dialectic, in Adorno's sense, of working through contradiction interminably, the panorama as 'circular' is significant as a critical response to the predominance of the (rectangular) frame that intercuts both the physical and psychical spaces we inhabit. Barthes writes in his lecture course, *How to Live Together*:

> Look at the spaces we live in: the majority of angles are at 90 and 180 degrees = houses, apartment buildings, doors, windows, roofs, lifts. . . . Since we now associate city, living space, humanity, and pollution, there's a pollution effected by the rectangle. . . . Rectangle: as the basic shape of power (Barthes 2013: 114)

To this, Barthes reminds us: 'The circle [is] something that's difficult to make [. . .] Robinson Crusoe makes all he needs in terms of furniture. He has no trouble making rectangles (tables, chairs, cupboards), but can't make a wheelbarrow, a barrel' (Barthes 2013: 115). Indeed, perhaps we might think of the panorama as an island, à la Thomas More!

VB: I'm led by association to Barthes' beginnings. Barthes begins *for us*, his readers, in 1934, with the diagnosis of his tuberculosis. For some fifteen years after, while he's preparing the intellectual foundation of his work, he is largely separated from the world. For most of World War II he was outside history, being treated with the means of the time, treatments that had not changed since the nineteenth century – silence, rest, clean air, sunshine, isolation punctuated by exchanges with fellow patients and the intrusions of doctors. During his three years in the student sanatorium at Saint-Hilaire-du-Touvet he had a panoramic

point of view upon the mountains, and as a tubercular patient he was also under constant surveillance – so he was a subject both of the panorama and the panopticon. As Barthes himself indicates, probably the closest we can come now to the world he inhabited during that time is the one described in Thomas Mann's *The Magic Mountain*. During Barthes' time in Saint-Hilaire the death rate in the sanatorium averaged three per day. The sense of a common human condition must have been no less acute for those in the sanatorium than it was for those under the occupation outside – as was, albeit very differently, the question of how to live together. Barthes' seminars at the Collège de France on the preparation of the novel, and on the question of how to live together, seem inescapably to reformulate questions that preoccupied him during those years of illness. Barthes' later interest in utopias must have more than a little to do with his early experience of hermetically enclosed monastic communities, but a monasticism founded upon devotion to the text and moreover one that required neither asceticism nor celibacy. In respect of my own relation to utopias, I've come to accept utopianism, the 'as if . . .', as an inevitable precondition for my work. For example, I make artworks as if commodification and spectacle, the sound bite and the one-liner, were not the ruling principles of the society into which they are produced, and the ruling principles of the 'artworld' produced by that society.

References

Ayer, A.J. (2001) *Language, Truth and Logic*. London: Penguin.

Barthes, Roland (1967) *Writing Degree Zero*, trans. by Annette Lavers and Colin Smith. London: Cape.

Barthes, Roland (1967) *Elements of Semiology*, trans. by Annette Lavers and Colin Smith. London: Cape.

Barthes, Roland (1974) *S/Z*, trans. by Richard Miller. London: Blackwell.

Barthes, Roland (1975) *The Pleasure of the Text*, trans. by Richard Miller. New York: Hill and Wang.

Barthes, Roland (1977a) *Roland Barthes*, trans. by Richard Howard. Berkeley: University of California Press.

Barthes, Roland (1977b) *Image Music Text*, trans. by Stephen Heath. London: Fontana.

Barthes, Roland (1982) *Empire of Signs*, trans. by Richard Howard. London: Cape.

Barthes, Roland (1985a) *The Grain of the Voice: Interviews 1962–1980*, trans. by Linda Coverdale. New York: Hill and Wang.

Barthes, Roland (1985b) *The Responsibility of Forms: Critical Essays on Music, Art, and Representation*, trans. by Richard Howard. New York: Hill and Wang.

Barthes, Roland (1989) *The Rustle of Language*, trans. by Richard Howard. Berkeley: University of California Press.

Barthes, Roland (2000) *A Barthes Reader*, ed. by Susan Sontag. London: Vintage.

Barthes, Roland (2005) *The Neutral: Lecture Course at the Collège de France (1977–1978)*, trans. by Rosalind E. Krauss and Denis Hollier. New York: Columbia University Press.

Barthes, Roland (2011) *The Preparation of the Novel: Lecture Courses and Seminars at the Collège de France, 1978–1979 and 1979–1980*, trans. by Kate Briggs. New York: Columbia University Press.

Barthes, Roland (2013) *How to Live Together: Novelistic Simulations of Some Everyday Spaces*, trans. by Kate Briggs. New York: Columbia University Press.

Batchen, Geoffrey (ed.) (2009) *Photography Degree Zero: Reflections on Roland Barthes's Camera Lucida*. Cambridge, MA: MIT Press.

Burgin, Victor (ed.) (1982) *Thinking Photography*. London: Macmillan.

Burgin, Victor (1986) *The End of Art Theory: Criticism and Postmodernity*. London: Palgrave.

Burgin, Victor (2006) 'Thoughts on "Research" Degrees in Visual Arts Departments', *Journal of Media Practice*, Vol. 7, No. 2, pp. 101–8.

Burgin, Victor (2008) *Components of a Practice*. Milan: Skira.

Burgin, Victor (2009) *Situational Aesthetics*, ed. by Alexander Streitberger. Leuven: Leuven University Press.

Derrida, Jacques (2001) *The Work of Mourning*, ed. by Pascale-Anne Brault and Michael Naas. Chicago: University of Chicago Press.

Elkins, James (2011) *What Photography Is*. New York: Routledge.

Knight, Diana (1997) *Barthes and Utopia: Space, Travel, Writing*. Oxford: Clarendon.

Lévi-Strauss, Claude (1969) *Conversations with Claude Lévi-Strauss*, ed. by Georges Charbonnier, trans. by John and Doreen Weightman. London: Cape.

Marty, Éric (2006) *Roland Barthes, le métier d'écrire*. Paris: Seuil.

Ungar, Steven (1983) *Roland Barthes: The Professor of Desire*. Lincoln: University of Nebraska Press.

Wood, Michael (2015) 'French Lessons', *Barthes Studies*, Vol. 1, pp. 6–16. Available online at: <http://sites.cardiff.ac.uk/barthes/files/2015/11/WOOD-French-Lessons.pdf>.

A Place to Read

Victor Burgin

A Place to Read is the earliest of the three projection works in the John Hansard Gallery exhibition. As explained in the following conversation with Ryan Bishop it was produced in 2010 in response to an invitation to make a work in Istanbul and was inspired by a partially disappeared coffee house by the Bosphorus. One of the work's intertitles informs the viewer: 'The Turkish word for "coffee house" is from an Ottoman word that means "a place to read".' The story told across the three sections of intertitles describes two acts of reading and an act of writing: a woman reads at a table in a coffee house overlooking the Bosphorus; a woman writes on the terrace of a coffee house in Geneva; a man is trying to read, in spite of the noise, in a coffee house on Istanbul's İstiklal Caddesi. The story the first woman is reading takes place in a parallel world in which the coffee house in which she is sitting has been destroyed. The story the second woman is writing is about a man and a woman whose avatars meet in a virtual coffee house the man has built overlooking the Bosphorus. The man in Istiklal Caddesi may be this man, whose virtual creation is imminently to be destroyed by speculation in virtual land. These mutually implicated scenes in turn may imply the coffee house described in the three image sequences of my work – itself a simulation in virtual space of the disappeared coffee house that inspired the work. *A Place to Read* was first shown at the Istanbul Archaeological Museum.

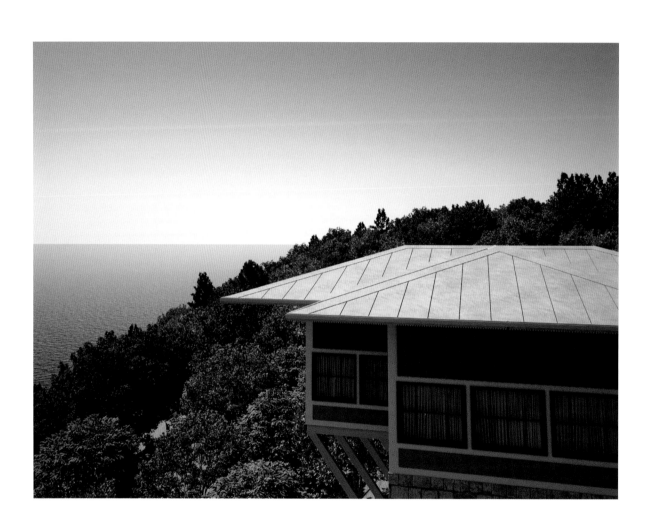

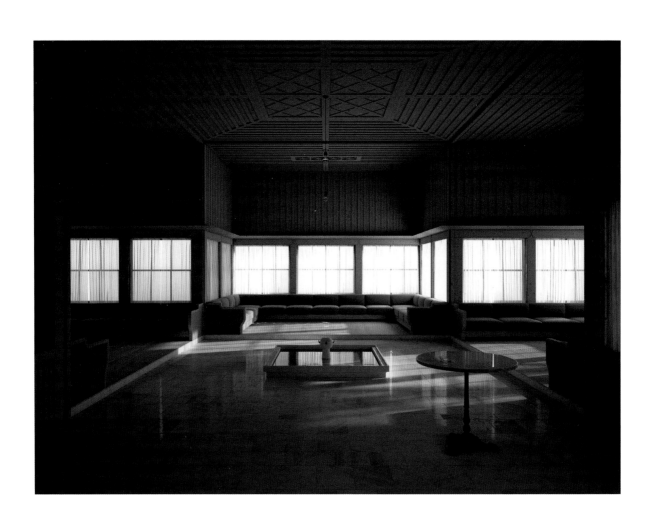

Still Moving

Ryan Bishop and Victor Burgin

The following conversation took place at the Winchester School of Art, University of Southampton, on 12 October 2015. Two of Victor Burgin's projection works, *A Place to Read* (2010) and *Parzival* (2013), were screened with no initial contextualisation. Each projection was followed by a conversation between Burgin and Ryan Bishop, with the second conversation moving into a Question and Answer session with the audience. *A Place to Read* is included in the show *Barthes / Burgin* at the John Hansard Gallery (2016), and images can found elsewhere in this book.

*

Ryan Bishop: I thought we would start with some of the background of *A Place to Read*. It was commissioned for the 'Lives and Works in Istanbul' project undertaken during that city's designation as the 'European Cultural Capital' in 2010. Can you discuss the genesis of the piece and the process regarding the decisions involved, such as the site explored, the reproduction of it, the materials used, etc.?

Victor Burgin: As I recall, there were maybe five artists commissioned that year to make works in response to their encounter with Istanbul. One of the problems for me in taking on a commission like that is to find the right tone, the right form of address. I hadn't been to Istanbul before, I didn't know the city and I didn't know Turkish culture. On the one hand, you want to make something which is truly a response to the city – you don't want to be one of those artists who takes whatever they've been working on in their studio and just transplants it. At the same time, neither do you want to appear to be 'revealing' the city to people who've maybe lived there all their lives. I read as much as I could about the history of Istanbul and about Turkish culture in general. I watched as many Turkish films as I could find and read a good number of Turkish novels in translation. I made several trips to Istanbul and stayed for more or less long periods of time. The hope is that gradually something will emerge from all the intersecting facts and impressions as an 'object', a kind of 'gestalt' outline of a place where a work may emerge. And in fact what did start increasingly to preoccupy

me was the sight of irreplaceable buildings, parks and other public spaces being mutilated or destroyed in the interests of private 'development' projects, frequently pushed through by the government in Ankara over the heads of local authorities. A few years later, as you may remember, there were massive public demonstrations against the Erdoğan government's project to turn a park in the heart of Istanbul – Gezi Park – to turn it into a shopping mall with luxury flats and a memorial to the glories of a pre-republican Ottoman past, and so people went onto the streets at that point. In 2010, though, the act of destruction I came to be most preoccupied with had already taken place. Before being invited to Istanbul I had a prior history of being invited to respond to cities, and very often that response involved photographing a building, but in this case the building I wanted to work with – a coffee house – was no longer there to be photographed.

RB: Because it didn't exist.

VB: Bits of it were still there – it had been pulled down, but parts had been moved to another position and reassembled as a kind of orientalist restaurant for the huge hotel complex – 'Swisshotel Bosphorus' – that was built in the 1980s on the site of the 1947 coffee house. The original coffee house was designed by Sedad Haki Eldem, a Turkish architect who had studied in Paris with Le Corbusier; it was a design that programmatically set out to draw on a traditional Ottoman architectural vocabulary while also incorporating elements of Western modernism.

RB: Very much in the Atatürk model.

VB: Yes, the equally Francophile Atatürk who wanted a modern Turkish republic – 'modern' in the sense of such things as the emancipation of women and the separation of religious and state authority – that historic project also was represented by that building, which was the other thing that made me want to work with that building rather than some other, because it did seem metonymically to represent the idea that Turkey could incorporate elements of Western modernity without compromising its national identity, its Islamic history. In that immediate post-World War II period the coffee house was a democratic 'statement' – anybody could go there and enjoy the view; if you want to enjoy the view from that site today you have to pay through the nose for a very expensive room in this awful hotel. So that was the building I wanted to work with. But it was no longer there, so what do I do? I can't photograph it so, OK, I'll work with a model. My first thought was to commission a maquette

and try to photograph an actual, physical model, but then I decided to use 3D modelling. At that time I had no practical knowledge of 3D software, so I worked with a couple of Istanbul architects who did 'architectural visualisation' professionally. They constructed the house and garden from the drawings and photographs we researched together, and then I was able to move my virtual cameras around the simulated site – which is more or less what I've been doing ever since.

RB: I was going to say – one of the reasons why we chose this piece to screen is that it constitutes an important shift in Victor's work, marking the movement towards virtual spaces and the use of CGI and game engines to build environments, which raises some issues we will talk about in a minute. I want to talk a little bit more about the site. This projection, *A Place to Read,* and its accompanying text bear witness to the excavation and salvage work that you gesture to through its content. Clearly there is a kind of excavation project that's going on with this and it looks at the 'unbuilt environment': that is, in order to build something and arrive at the built environment, one has to unbuild something that occupies that space. In this case what was unbuilt was this beautiful coffee house. And as a result, during the initial installation of the piece you showed it at the Istanbul Archaeological Museum, and so in a way it's obviously about the past. But also as you said it had this prescient, proleptic dimension insofar as it anticipated some of the discontent that people were feeling with the government's neoliberal market-driven property agenda. There was and remains a good deal of discontent surrounding the remaking of the city that entails building certain parts of it in very specific ways and thus losing a kind of collective spatial memory as well actual public space. Further, in your text you also have that proleptic gesture operating at several evocative levels: with regard to the environment, with regard to discontent in Istanbul and within Turkey, and with loss and historical memory being embedded in architecture and disappeared buildings. I was wondering if you could talk a little bit about showing something in a particular kind of site: the Istanbul Archaeological Museum, showing it here, or elsewhere than its original installation site. What does it mean to link a work that is about site, memory, and loss and erasure, and anticipate different modes of temporality with regard to a space, and then move that to other sites?

VB: Well, as originally commissioned, *A Place to Read* was a 'site-specific' work, the specificity of the site being of course that of the city of Istanbul itself. Installing the work in the Istanbul

Archaeological Museum, rather than in a more neutral gallery space, underlined the local historical and political meanings of the work – in effect, the context of the museum became part of the work. So, as I began by saying, making work to commission I have a sense of obligation to the immediate local context, a sense that the work should be strictly relevant to that specific context; but at the same time I also feel that it should be possible to move the work, to install it somewhere else, without it losing all of its original meanings. In a paradoxical way the specificity of the work should be generalisable, applicable in situations other than the one in which it was originally produced. Apart from the fact that the spoliation of public space by private greed is hardly confined to Istanbul, I also felt that to shift the mise-en-scène of that topic into virtual space – I was thinking about 'Second Life' and similar uses of Internet space – I thought that might allow the work to be engaged with by people with no particular knowledge of Istanbul. At the other end of the scale, there are references that will only be picked up by people who know Istanbul. For example there's a reference to İstiklâl Caddesi, which is the 'main drag' in the Beyoğlu district, one of the first places that tourists head for. But then the reference to the woman at the table of a bistro in Geneva, although perfectly understandable to anyone who reads it, will only take on its full import if you know something of modern Turkish intellectual history, a history full of Turkish writers exiled or self-exiled in Western Europe. One of them, Aslı Erdoğan, published an autobiographical–fictional account of her time in exile in Geneva – *Miraculous Mandarin*. Of all the Turkish works I read that was the one that stayed with me the most. When I was looking for more of Aslı Erdoğan's work I came across a photograph on the web of her sitting at a bistro table. That's the photograph I describe in the 'Geneva' intertitle section of my work, and that's the table with the ashtray that you see in my work, incongruously transported to that Ottoman-style coffee house interior. It's an incongruity consistent with the architect Eldem's hybrid sources, as well as with the incongruities of encounters in virtual space – whether computer space or the space of dreams. But who's going to be aware of the source of that particular image apart from myself? Probably no one. But I feel it's important to have such archival materials as points of departure because they ground the work in the factual. The imagery has to come from somewhere so why shouldn't it come from something real? My works are not 'documentaries', and I don't exhibit my research materials, but the visible contents of the work – texts and images – all have their origins in documented facts.

RB: It gives the work another layer.

VB: Yes, that layering of references, of potential meanings, is a response to the particular

circumstances of viewing, and spectatorial position, in relation to work like this.

RB: Which is an installation . . .

VB: . . . yes, an installation, and not intended to be seen under these present conditions. In an educational context we accept that we look at things that are sometimes badly presented, that are shown under inappropriate circumstances. We accept that for research reasons and make the necessary allowances. But what we are in here, of course, is a theatrical situation, a cinematic situation, whereas my works are made to be shown in museums and galleries.

RB: And in the context of the gallery, unlike here in a lecture theatre, the important point to note is that your works are set on a loop.

VB: Yes, in the cinema people normally go in for the beginning of the film, at a specified show time, and everyone together watches through to the end. In a gallery people very rarely have that kind of relationship to a work. Individuals come and go at unpredictable times, and stay for indeterminate periods. It's a form of spectatorship that belongs to the history of painting rather than cinema. My works loop in response to that kind of behaviour. I expect people to be unpredictably coming and going. Some will sit through until they think, 'This is where I came in'; others will sit through two or three iterations. I know that many people have no problem doing that. I do it myself with works by other artists. You will sit for as long as you feel there is another layer you can take off, like peeling an onion. It's a mistake to equate the loop with repetition. It can be, but it needn't be – meaning needn't come to closure in a circle; it can develop in a spiral. So rather than spreading the story out in time, the way it unreels in the cinema in one single line, it is rather a matter of revealing the story through successive layers of possible meanings, so that each time you go around you have the chance of reinterpreting and making connections that perhaps didn't occur to you the first time around. So that's part of the specificity of this kind of work, which is very different from the specificity of the theatrical situation, or the specificity of watching videos on YouTube, or watching television at home, or a clip on a mobile device. These all have their own specifically different modes of spectatorial engagement, and one has to take that specificity into account.

RB: Yes, and part of that has to do with a kind of temporality in which the traditional Western linear narrative trajectory is not possible, or even perhaps desirable. So the

work as we just showed it a few minutes ago was in a sense misrepresented because we showed it from a beginning of sorts through to an end of sorts. We took one turn of the spiral and flattened it out. But the narrative structure of that line, visually and textually, presents particular challenges in that it makes each point in the loop metonymic of the whole, so that any point of entry is a legitimate point of entry, and should be arresting enough in and of itself and link enough to the whole to be successful.

VB: That's the challenge for the writing, and for the imagery, because if your viewer is walking in and out of the gallery at unpredictable times, then any image can in principle be the first image for that person, any sentence can be the first sentence. If you go into a cinema in the middle of the film, you know you've walked in after the film has started, you get that feeling of having missed something. When I'm making my own works I feel that you should be able to start anywhere. As you say, we played the work we just saw as if from beginning to end, and in fact that's largely the way I compose it, but while I'm writing I'm always thinking of the loop. That's the basic formal requirement of this kind of work, albeit it's a theoretical requirement that's very hard to meet in practice.

RB: I would imagine so.

VB: For all kinds of obvious reasons. But I was consoled by a short essay a friend recently showed me by the Canadian writer Alice Munro, a piece about how she reads and writes short stories. [Alice Munro, 'What is Real?', in *Making it New: Contemporary Canadian Stories*, ed. by John Metcalf. Auckland, Methuen, 1982.] I was really surprised by how closely what she says fits my own experience. She says that when she writes a short story, and even when she reads short stories by other writers, she feels she can start anywhere. She doesn't necessarily start at the beginning. She also feels she can return to the story and read again from a different starting point. And she says – it's an image that's been very helpful to me in describing my own work – she says that she doesn't think of her stories as roads but as houses. You don't travel in a single direction, taking in the sights until you get to the end of the road. You go into this room, you wander out, you go into another room and maybe stay a little longer, you keep coming and going and in addition to seeing the room you get different views of the outside. And she says . . . it gets even better . . . she says there's always a central room, but that's dark. Now she says that the 'dark room' is the dark incident that so many of her stories relate, but in another part of the essay she says that her stories

are always built around an 'indescribable feeling' that she can't describe in any other way. So I would say that the really dark room is that feeling, 'dark' not necessarily in the sense of unpleasantly disturbing, like the anecdotes she relates, but dark in the sense of being obscured from direct knowledge. So there's a kernel of affect that if we were looking at this in a psychoanalytic framework we would say is the indicator of an unconscious fantasy – which, by definition, is obscure, but which the story you write will be built around. Another analogy, one I've used most often before I found Munro's house analogy, was one taken from the story of *The Invisible Man*.

RB: The early film version . . .

VB: Yes, the film version, where of course the problem is 'how do you film the invisible man'? By definition he's invisible. So various devices are used – such as the bandages he wears.

RB: Nobody knows why he needs bandages, other than to show his form.

VB: That's right. There's one scene in the film where he's running from the police and by implication is totally naked, but he crosses a snow-covered field and you see his footprints in the snow. But the scene I prefer as analogy is the one where he's in the street, and there's a lot of detritus, old newspapers and stuff, and suddenly a wind blows up and all this stuff starts sticking to him and he's suddenly there, you see him. But of course you don't: you never see the invisible man, you only see the stuff that sticks to him, which can be anything. And that's the way I feel it is for me when I work – and probably the way it is for anybody else – I feel there's some je ne sais quoi, Munro's 'indescribable feeling', the 'dark room' at the centre, that you can never see, that you can only kind of stick things around and hope that some sense of its shape will emerge. But what results from that process of collage, or graffiti, is never right; it will always disappoint, and the disappointment in what you've done makes you want to try again.

RB: I think there's an allusion to that street scene in Terry Gilliam's *Brazil*.

VB: Yes, that's right.

RB: Where the newspapers and scraps of paper blow around, and he gets swallowed up in the paperwork. Well, this leads me very neatly to your book *The Remembered Film,*

and the idea of 'cinematic heterotopia' that you engage there. The cinematic heterotopia addresses the ways in which elements of cinema exist far beyond the cinema and the film-watching moment. It's an imaginary space of hybrid materials that we encounter through a heterogeneous variety of fragments, a film beyond the spatial and temporal confines of the movie theatre. The film acts as a prompt or catalyst for the construction of memory. Therefore as one moves around in the world, the cinematic heterotopia ignites ideas and connections that reach far beyond the limits of the film helping to create the world and our experience of it in the ways that any discursive formulation might but with the added sensorial input of vision, sound and touch. It seems to me that this book is the intellectual ground-clearing that leads to your projection work. Can your projections also be seen as evoking or manifesting 'cinematic heterotopia' through cinematic tools, direct and indirect allusions (especially of European film), and even the space in which they are encountered (a gallery as opposed to a cinema theatre, TV screen or computer screen)? As a result of your engagement with built and unbuilt environments, too, we find a modified version of Foucault's architectural heterotopia in your cinematic heterotopia.

VB: Yes, if we were to stay with the analogy of the 'invisible man' then we would say that among the things that stick are fragments of remembered films, which is to anticipate the next work of mine we'll be seeing, *Parzival,* which was commissioned for the Geneva Wagner Festival, a couple of years back, and embedded in that work I have a fragment from Roberto Rossellini's film *Germany Year Zero* – that's an element that came to mind, as something that could, as it were, 'stick to the invisible man'. So, that film fragment is part of the heterogeneity you mentioned, along with the computer-modelled scenes, intertitle texts, fragments from the opera Parsifal . . . Although these elements necessarily appear one after the other, I don't think of them as a unified linear chain so much as a succession of relatively independent events. All of those bits, one feels or hopes, through working, will gradually start to reveal something of that je ne sais quoi that was, in this case, my response not to a city but to the work of Wagner. I wasn't a Wagner buff before, and have not become one as a result of working on Wagner, although I know a lot more about Wagner than I did before I started – a stunning, extraordinary person . . . but it was a response to, in this case as I say, a kind of abstract object, the corpus of the work of Wagner, who interestingly considered himself to be a poet before anything else. There's a wonderful letter that he wrote to Liszt, a close friend of his at that time, in which he says something like 'At last, after so much labour, my Siegfried is finished; now all I have to do is write the music.'

RB: The music to him was secondary . . .

VB: . . . Yes, at the outset he considered himself to be above all else a great German poet, and there are those who still agree with him. He just happened to revolutionise Western music along the way. He was also of course a great innovator in the theatre, and had an idea of theatre that was . . . well, he himself would not have said it was unique, because he would claim he took it from the Greeks – but it was certainly revolutionary. And he was also an innovatory theatrical architect – he designed the architecture of the opera house at Bayreuth, the Festspielhaus.

RB: Yes, his was an immersive art, his *Gesamtkunstwerk* . . . fully sensorial. Perhaps we can return to this kind of immersive experience shortly, as I want to talk about game engines, and 3D modelling. However, let's stay with Wagner and show your work *Parzival...*

RB: Wagner's operas, as well as in this instance the medieval tale that underpins it and that gripped Wagner's imagination, seem almost wholly antithetical to your own works. I know you were commissioned to do a piece for the bicentenary of Wagner's birth, in 2013. Can you provide a bit of background about this piece, the commission and its relation to your interests in opera (which are not necessarily Wagnerian), as well as some of the choices you made with it: sound, texts on walls, black and white with colour tinges, colour, tracking shots, borrowed clips, 3D modelling, fractal modelling of the waves etc.?

VB: The commission came to me via the director of MAMCO, the Museum of Modern and Contemporary Art, in Geneva. We'd worked together previously, and he knew of my interest in opera. What he hadn't taken into account was the fact that my interest was in Baroque opera, especially the French Baroque. Although I was surprised, when I checked my shelves, to find how many Wagner discs I seemed to have acquired along the way, I was really starting from scratch in terms of any real knowledge of Wagner. So in the case of this particular commission, part of that sense of obligation I mentioned earlier took the form of a feeling of responsibility towards that part of the imaginary audience who knew their Wagner, which launched me on a long learning curve. But at the same time, again as I mentioned before, the work also had to be capable of engaging a spectator indifferent or even hostile towards Wagner. I say 'capable' – one can never *impose* an engagement on the part of the viewer.

RB: What were some of the other impulses behind the work, especially with various intertextual dimensions, including Rossellini's *Germany Year Zero,* the aria from the opera and indirect allusions to the thirteenth-century chivalric romance it sprang from? How do these add up to the work being a 'representation of a psychological object' as you have called it? How do the different elements, multiple allusions and layering of images, sound, text, references, etc., 'ground' the work? How does the range of textual sources ground the work spatially and temporally? How does it ground the work in a kind of spatiality and also evoke a range of temporalities for you?

VB: When we spoke about the work for Istanbul I gave the example of the photograph of Aslı Erdoğan writing at a French bistro style table. I found the image on the Internet. It's low in information – small in size, low resolution, with no accompanying text. My best guess is that the writer is in the lobby of a large Turkish hotel, probably in Istanbul, maybe one of

those large European-style hotels on Taksim Square. In one of my intertitle texts I transpose the writer and the table to a café terrace in Geneva. The context is changed but the scene remains historically plausible. It might easily have taken place in reality. The text says there is an ashtray 'in the foreground', which signals the fact that what is being described is an image. Elsewhere in the work, in one of the three computer-modelled scenes of the coffee house interior, you see the table with the ashtray as described in the intertitle – a remnant of the original scene now inserted into a third context. A metonymic chain has been set up between a transient event in the real and the surface structure of my projection piece, but in the process the original material has been broken up, translated, scattered, recontextualised. The procedures when I write, produce images and assemble these together are analogous to the processes of memory, fantasy and associative thought that accompany the work of research. The surface structure of the eventual work follows the lines of these processes and procedures, much as the surface of a terrain follows the lines of the geological strata it both conceals and reveals. To take another example, the clips from *Germany Year Zero* you mention, here the film – unlike the photograph of Aslı Erdoğan – is not at the origin of a chain of associations but, as it were, at their termination. Thoughts of Wagner, his early days as an incendiary revolutionary, the flaming destruction of Valhalla that closes the Ring cycle of his later days, these thoughts perhaps inevitably lead to the World War II fire bombings of German cities. Rossellini's documentary footage of Berlin's ruined streets represent that association, but what appears in my *Parzival* piece is not Rossellini's footage as such but my own reformulation of his footage in terms of operatic scenography, and in terms of computer modelling, particularly the theatrical domain of computer game space. Rossellini puts a fictional character, the small boy, in a real environment. I put Rossellini's real boy in a fictional environment. A more media-historical way of looking at it would be to see the clips of the boy as indexical images from the cinematic archive insert edited into a contemporary space of simulation.

RB: Our title for this conversation is *Still Moving* and it plays with the idea of still imagery and moving imagery and the gaps between these motile states that are possible with perspectives achievable through 3D modelling with computers. In a way, CGI allows one to enter a two-dimensional still image and move about in it and do some things with it. And this becomes, then, kind of like a Möbius strip where there is no inside or outside per se. How does that 'still moving' conceit function in a projection such as *Parzival,* or *A Place to Read,* for you? How does the dynamic of the computer-generated alterations to perspective suggested by these game engines and

the environments they create find articulation in the simultaneous multi-temporalities offered in your texts for the work? Might the texts provide temporal versions of the Möbius strip possibilities of the *in potentia* spatiality game engines can generate?

VB: Well, although I've spoken to you about my interest in game engines, this has been a largely theoretical interest to date. 'Learn Unreal Engine' is on my 'To Do' list, but I haven't yet found time to take more than a few first steps. This and all my other concerns though can be ranged under the common rubric of 'perspective'. I've already said it's important to me to take into account the specificity of the location of these works in art museums and galleries. For example, I accept the customary behaviour of spectators in such places. I don't ask them to behave any differently from the way they behave when they go to look at a painting. That's the representational tradition out of which my work emerges – not photography, not cinema. Maybe it's this background that has allowed me to relativise photography and cinema, to see these forms as historically contingent stages in the history of the perspectival system of representation, and to see computer simulation as the latest iteration of the way the West has represented itself and its others since the early fifteenth century.

RB: So in a way your engagement with CGI is a bit more like painting . . .

VB: It's a continuing engagement with the history of perspective . . .

RB: It's like your panoramas from the past where you have the zero degree, essentially, where you stitch together the digital imagery. You have a panorama but with an impossible perspective from which to see it. You get a perspective but there's no physical place in which one could possibly stand to get it.

VB: Yes, it's an incorporeal vision, in at least two senses. A real person, operating an actual movie camera, can never make a perfectly regular panoramic movement, whereas the movement of the virtual camera can be perfectly constant – for all that bodily movements and camera jitter can be simulated in software if required. More fundamentally, the image produced by the real camera will contain parallax effects – for example, an object in the background may appear first to the left of a foreground object and then move to the right as the camera continues its movement – but this can't be allowed to happen when stitching stills together; otherwise a seamless match of images will be impossible. The only way to avoid parallax is to have the 'nodal point' of the lens, the virtual point where the light rays

intersect, exactly coincide with the point around which the camera rotates – which is a point of view that cannot be physically embodied. I no longer use a still camera for shooting panoramas. The panorama in *Parzival* is made entirely in the space of 3D simulation, and in this space the laws of physics are different, and that's something I'm becoming increasingly interested in. The space of 3D modelling can look perfectly familiar, not least because it's modelled in perspective, the lingua franca of Western visual representations, but it's a space that needn't obey any law of physics that applies in the real world – apart from optics, maybe. This is a realisation I had when I put that ocean in towards the end. I was looking at this ocean, which is of course 3D-modelled, and I was thinking that the waves didn't look right – they kind of 'tear' in a completely unnatural way. But then I thought, well, of course, they're not real waves, they're something else, in a different world, and in that different world that's what they do. That's what I'm interested in now is this world without air and without gravity, where things behave differently – for example, where two bodies can occupy the same space at the same time. So that's something I want to work on more, the physics, or a-physics or anti-physics of computer-modelled space, which can be at the same time both perfectly familiar and totally unreal.

RB: So it's a bit like an extending of but undermining as well at the same time of the metaphysics of cinema, because cinema allowed us to manipulate time and space in very specific ways. I mean you can run things backwards so that you can – to borrow a line from Brian Eno – you can put a grape back on the vine, by running it backwards.

VB: That's right, which was one of the first things that interested people in the earliest days of cinema . . .

RB: That capacity, too, to stop the film when shooting and to change things within the frame, and start shooting again to create the illusion of things appearing or disappearing immediately, which is what mesmerised Georges Méliès in the early days of cinema.

VB: . . . and I find myself getting excited about the possibilities in all of that and then think: 'Oh, have I just discovered animation? Big deal!'

RB: Yes, the Fleischer Brothers, they've done that already! But it is giving you a different set of tools to play with, to think through perspective, because as we've discussed before in different venues so much of what's been done with computer-

generated environments is what happens when any new technology comes along. It documents what it is replacing, and computer-generated imagery has done a fantastic job of storing up Quattrocento technological perspectival and technological modes of representation. But do you see your work as stepping beyond that, or having the potential to do so?

VB: Perhaps what I see as a potential is less of a 'stepping beyond' and more in the nature of the spiral movement we talked about earlier. The various practices that are emerging in our time of 'post-cinema' are also invoking pre-cinema. For example, you could describe the two works we've just screened as silent movies with intertitles. The description is accurate, but would be totally misleading if offered to someone who hadn't actually seen the works – which neither return to early cinema nor move existing cinema forward: they rather spiral back through cinematic memory to lift away from cinema.

RB: OK – well, we've got a few minutes left here, and with that we can open the floor to questions and comments.

Audience Member #1: I'm really interested in the loop as a structure, the loop and how important it is in terms of content, as well as in terms of people going in and out of galleries. And you mentioned Philip K. Dick – I'm not sure if this is the reference, but he refers to *Parsifal* where I think it's Gurnemanz says to Parsifal: 'here space becomes time'. It's really interesting in that one wonders where did Wagner get that idea from, and it occurred to me that that's quite possibly a description of the loop as a structure. Is that how you're thinking? I thought you were going to mention Philip K. Dick because of that connection to *Parsifal.*

VB: I talk about Philip K. Dick, certainly, in some things I've written, but I'm not sure it's in that work as such.

RB: I thought it was in one of the wall texts but I might be wrong.

VB: OK, I'm sorry, you're right. I didn't talk about that part of the work today, but when *Parzival* is actually installed in a gallery context there is a whole apparatus of wall texts, and Philip K. Dick is 'referenced', as they like to say, there. I think Dick's reference to *Parsifal* is in *Valis*. But the reference in my work is to *Martian Time-Slip*, where a principal character is

this autistic child – who I associate with the Parsifal character – or at least he's assumed to be autistic, but his 'problem' is that where everybody else is seeing what is present he only sees what that present will become in the future.

Audience Member #1: Yes, he draws the new apartment block as a ruin . . .

VB: That's right, everyone is marvelling at this new apartment block and he's just seeing a ruin.

RB: Which is a bit like *A Place to Read.* We see the building as it was while knowing it is ruin now. I think we all agree that the loop is a really interesting structure, and it's one that links to cybernetics as well as to a whole host of related concerns of the means by which information operates within a loop. A loop repeats but, in doing so, proves there is no such thing as repetition, or so cybernetic theory argues. The loop links as well to Derridean notions of iterability insofar as the question of what is primary in a sequence becomes foregrounded: which is the first can only be established by the second that establishes the first as the first. The first one depends on the second, as it were, to constitute it as primary.

VB: And it's also the ritornello form in music – if a refrain or phrase comes back then the second time it's heard it's not the same, because your second hearing of it is informed by your memory of the first time and by what's come in between. So there is no repetition; it's not a circle it's a spiral; it's continually spiralling and lifting off from itself – potentially infinitely, because there's no end to the potential input of the viewer. In principle, the viewer's mind is working all the time and elaborating on the material because there's enough 'space' in the material to allow that process of elaboration, whereas conventional narrative fills in the spaces. As Barthes says, in the cinema you're 'not allowed to close your eyes', whereas in 'uncinematic' works like this you are.

Audience Member #2: Yes, you're very much of the school that says it is not the teller that tells the tale. It's something I know you've written about – that the interpretations are primary, not the authors' intentionality. But at the same time, clearly, you are not primarily motivated by communicating with the outside world per se. It's an internal conversation you are having. So how do you square those two sides?

VB: I don't see my works as being about a kind of Romantic communion with my inner life.

I don't see my work as being about 'communication' either – which is usually impossible outside of such controlled contexts as road signs. One's inner life is always there – as one's inner life always is, so you can't deny it – but at the same time my works engage with a common object, a public object. I started by discussing how I try to think about who my public is, how to address them, how to put something out there which is both the object I'm working on and working with, and at the same time an object that they are seeing too, as an object in their own space and time. The object, whether it's a coffee house or the works of Wagner, becomes a kind of crossroads where my own responses, intellectual and emotional, intersect with those of others – or possibly where they just cross, without understanding or even acknowledging each other, which is in the unavoidable nature of things also.

Audience Member #3: You use computers to make your works, I wonder if you've ever thought of making interactive works.

VB: I have thought about it, but to date I've always decided against it. One reason of course is that the works are already interactive, in the sense I've already mentioned, in the viewer's interpretative activity. But all works of art are 'interactive' in this sense – the sense, for example, in which we 'interact' with a novel when we form mental images while reading – so it's not really answering your question. It has occurred to me that if I'm serious about the general idea of specificity then I should perhaps make more use of the interactive capabilities specific to computers. Here, though, I've come to accept that just because you can do something, it doesn't necessarily follow that you should do it. With maybe one exception, a work called *The Waves* by the French artist Thierry Kuntzel, I haven't yet seen a software-driven interactive artwork that I actually liked. I find that having to press things, or slide things, or wave my arms or otherwise dance about . . . I find all of that gets in the way. I'm looking for a more contemplative relation to the work, one that encourages a different type of immersive experience than that offered by actual physical activity. Something that I find more interesting, and feel I should perhaps try to explore, is the capacity of the computer for parametrical variation. For example, I could in principle allow an algorithm to introduce variation into my intertitles, or images, when the material loops. But, again, I haven't yet seen an example of this kind of database-permutational approach that I've found anything more than amusing, which is not to say there is no potential for anything more interesting. I'm hoping that if I ever find the time to explore game engines in depth I may come across such a potential.

Audience Member #4: I don't know how interested you are in ontological incompleteness in the black and white video game and the distant buildings without any interior and how that might relate to the house you mentioned in the Alice Munro essay. So is it the anti-physics within that virtual world that interests you or is it the ontological rifts we might actually have within the universe itself?

VB: When you mention video games I think again of Barthes, who says he doesn't go to the theatre but it's always there in his work, in his consideration, and I've come to feel that way about video games. I have always, ever since a child, hated playing pre-packaged games. I think video games are really interesting; I just wish I didn't have to play them to learn about them. So I've read about them quite a lot, which is the way intellectuals experience life, and I've looked at them. In fact I sent one to Ryan, but it's barely a game. People are arguing about *Dear Esther:* 'Is *Dear Esther* a video game or not?' I don't know, I found it interesting. You're let loose on an island and you can just wander anywhere you want. The wind's blowing, it's kind of melancholy, you can hear the seabirds and the sea, there are ruins and other signs of previous habitation. You hear fragments of voiceover narrative from time to time. And you start to form a picture of the history of what may have happened on this island, but you also form a picture of what's happened in this individual's personal life. And I found that really interesting.

RB: There's no real goal, though, is there?

VB: There's no goal, no.

RB: Which is quite nice.

Audience Member #5: I know the game and I know the company that made the game. All of their games are based on walking through a space and finding the narrative, and making it up for yourself, and uncovering it for yourself, and you being sort of in control of what you take from that narrative, it's still muddled towards the end.

RB: Because it's got a narrative closure, as it were.

Audience Member #5: Yeah, the idea is that you are engaging this place that they have made which is so life-like that the focus is on the environment. The software

that they use to make games is mimicking the world.

VB: It's a very obvious thing to say, people say it all the time, but we might look to video games for the next historical shift in the history of storytelling through the moving image. But videogames, or 'computer games' as we might better call them now, have been around for a while – why hasn't it happened yet?

Audience Member #6: I just wanted to go back . . . you were telling the story about how you discovered this three-dimensional world which is able to be liberated from physical laws, but I wonder at the same time whether you think there's something you've lost, that you have let go of something real-world and your relationship to it that you regret. I mean it's not irreversible . . .

VB: Yes, I know what you're talking about, but may I answer by asking you a question? It's a question I ask myself. Do you think that something of that which is lost comes back when I include, to take the example of *Parzival*, the clip from Rossellini? You see a photographic image, a film image, does that – albeit paradoxically, as we're talking about a fiction – bring something of that real world back? Brings it back if only in the form of nostalgia perhaps, which is the way I think about cinema and photography now. I think that ones relation to that century and a half of photography and cinema, inevitably, has become nostalgic. You know, I find it very difficult these days to make a photograph, just as there came a point in time when I could no longer paint. I trained as a painter, I have a First Class Diploma in painting from the Royal College of Art. My first exhibitions were of paintings, but it got to a point when I could no longer paint. It became nostalgic: you put this stick in your hand with bristles on it and dip it in the coloured goo. . . . What am I doing? Where am I in time when I'm doing this? Which is maybe just a personal problem, but after that nostalgic relation to painting, and the sense that I couldn't do it because it had all been done already, I developed a great excitement for photography. I discovered it comparatively late in life, taught myself how to take photographs, looked at works by 'great photographers' – that was a very exciting time. I learned a lot from it. I used photography for a while, then suddenly that too . . . I suddenly felt, I can't take another photograph. And I'm hoping I'll die before I get to the end of my interest in 3D-simulation! It's an endless learning curve, not least because, unlike painting and photography, it's a technology which is perhaps unlikely to achieve any definitive efflorescence, and therefore obsolescence, as it's an epiphenomenon of our now fundamentally algorithmic existence.

Prairie

Victor Burgin

Prairie was made in 2015 as part of my contribution to 'Overlay', a research project at the University of Chicago undertaken by myself and the philosopher D. N. Rodowick. In its simplest architectural application the word 'overlay' refers to a drawing traced over a prior drawing. The Overlay project focused on the history of 'The Mecca' apartment building, built in 1892 and demolished sixty years later as part of the expansion of the then Illinois Institute of Design (now IIT) under the plan of Mies van der Rohe, whose 'Crown Hall' building now occupies the Mecca's former site. *Prairie* was prompted by a promotional brochure for the IIT College of Architecture, picked up on a visit to Crown Hall. Entitled *Nowness* the publication, amongst other things, states: 'Mies's scheme for IIT first cleared a space in the surrounding urban fabric and then placed a carefully choreographed set of low-slung buildings on the new park-like campus.' The brochure does not say that the space cleared had been the South Side's most vibrant centre of African-American culture – the 'Stroll', a stretch of State Street between 31st and 35th which flourished as business district by day and entertainment center by night. It does not mention that 'The Mecca', at State and 34th, was demolished only after a decade of resistance by its occupants. The IIT campus around Crown Hall is landscaped to evoke the prairie – a natural habitat now all but disappeared from 'The Prairie State', as are the native peoples who once lived there. *Prairie* was first shown at the University of Chicago's Neubauer Collegium in the context of the 2015 Chicago Architecture Biennial.

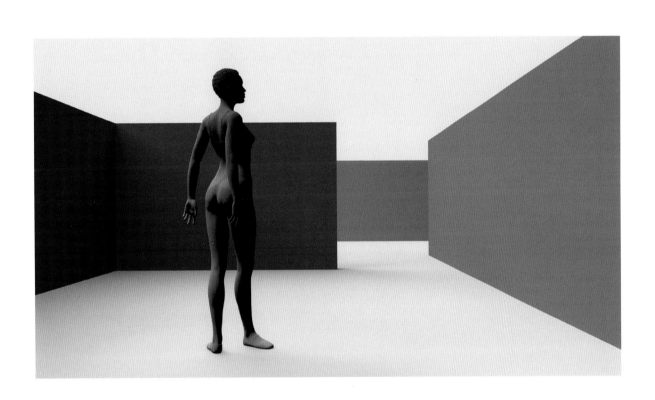

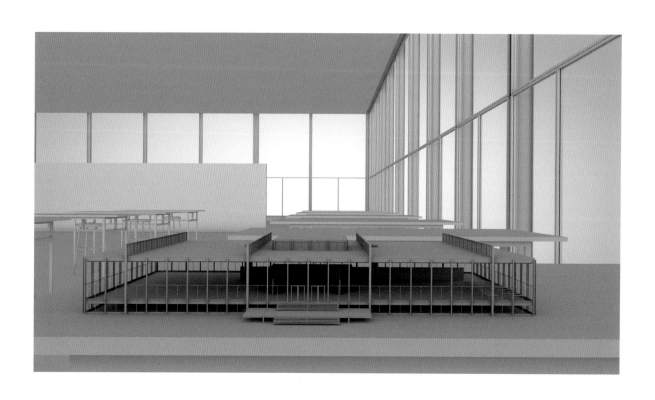

Belledonne

Victor Burgin

At the time of writing, *Belledonne* is a work in progress. It was commissioned by the John Hansard Gallery, which formally opened at the University of Southampton in 1981 with the exhibition *The Panoramic Image*. The final exhibition at the Hansard Gallery before its move to new premises in Southampton city centre will comprise works on paper by Roland Barthes and three projection works by myself. I thought it appropriate to inscribe references in my new work to the first and last shows in the original Hansard building. Belledonne takes its point of departure from a postcard from St-Hilaire-du-Touvet in southeast France, where from 1942-5 Barthes was a patient in a tuberculosis sanatorium. The postcard shows a panoramic lookout point with a view of the Belledonne mountain range in the French Alps.

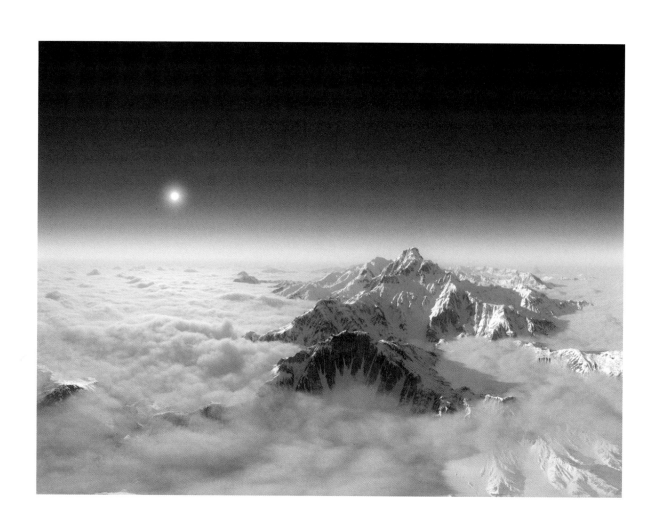